D1070906

THE FRESCOES OF MANTEGNA
IN THE EREMITANI CHURCH, PADUA

THE FRESCOES
OF MANTEGNA

IN THE EREMITANI CHURCH
PADUA

TEXT BY GIUSEPPE FIOCCO

WITH AN INTRODUCTION BY TERISIO PIGNATTI

PHAIDON

RECEIVED

DEC 2 8 1984

Oversize
ND
623
.M3
A4
1978a

Phaidon Press Limited, Littlegate House, St. Ebbe's Street, Oxford
Published in the United States of America by E. P. Dutton, New York

First edition © 1947 by "Silvana" Editoriale d'Arte, Milan
Second edition © 1978 by "Silvana" Editoriale d'Arte, Milan
All rights reserved
English translation © 1978 by Phaidon Press Limited

No part of this publication may be reproduced, stored in a retrieval system, or transmitted
in any form or by any means, electronic, mechanical, photocopying, recording or otherwise,
without the prior permission of the publishers

ISBN 0 7148 1899 2
Library of Congress Catalog Card Number: 78–56684

Colour photographs, reproduction, printing and binding by
Amilcare Pizzi SpA, Milan, Italy

INTRODUCTION

I well remember a visit to the Ovetari Chapel soon after my twentieth birthday. What made an unforgettable impression on me was the brilliance of some of the colours, the bright emerald green, ultramarine blue and coral pink, in contrast with skies that were leaden grey as during a thunderstorm. I also recollect the enchanting marble architecture, so white and gleaming, so cold and classical. Now, after so many years, I can still call up in my mind, in perfect clarity, an image of those frescoes of Mantegna which alas no longer exist. Yet I believe firmly that the impressions, such as I see them before me, are trustworthy, conjured up gradually by the visual memory rather than by the intellect, almost like imperfectly scanning lines of a poem that is no longer distinctly remembered.

In 1940 the war had already broken out, and it was five years before I was able to return to Padua. The Eremitani Church, with the marvellous chapel, had almost disappeared: a bomb had hit it on 11 March 1944. It so happened that, when I resumed my studies after serving in the forces, I was soon to hear again of that lost masterpiece — and the speaker was none other than Giuseppe Fiocco, who had become my teacher in Padua. I clearly remember how his voice trembled with emotion and how passionately he spoke when describing the lost frescoes, how sparkling and incisive was his delivery, which enthralled all who listened. I still seem to hear the grief in his voice when he saw before him the dreary grey slides projected by an ancient magic lantern. And yet, in those words the marvels of the Ovetari Chapel seemed to come to life again, and for me, who could remember them, they took shape at once.

By great good fortune, Mantegna's frescoes had been photographed in colour shortly before the catastrophe, and thus Fiocco was able to publish in 1947 these precious records, together with his text. That book is here being republished, and now that he is no longer among us I am glad as well as proud to be able to add a few pages to bring it up to date. Two of the frescoes have survived: the *Assumption of the Virgin* and the *Martyrdom of St. Christopher*, which happened to be elsewhere when the disaster struck. But we must also be grateful that this volume of colour reproductions has been preserved and can again be made available to the readers of today.

Since 1947, when Fiocco's text was first published, much progress has been made in Mantegna studies. To put it briefly, the process of rediscovery begun in 1927, when Fiocco himself recognized Mantegna's role in the Eremitani as a pioneer of Renaissance painting in northern Italy, is now complete. The fundamental contributions of Roberto Longhi (1926) and C. L. Ragghianti (1937) were followed by the wide-ranging and thorough revaluations of Erica Tietze (1955) and Rodolfo Pallucchini (1956-7) — almost like a prelude to the Mantegna Exhibition in Mantua, organized by Giovanni Paccagnini, which opened a new decade of valuable studies (see the Bibliography on p. 43).

[5]

593109

The view of Mantegna enshrined in the literature of the first half of the twentieth century did not, on the whole, conflict with the picture that Vasari had given of him in 1568, a picture in many respects well-informed and still quite valid: that of a painter of great technical ability, a realistic and educated interpreter of classical antiquity as represented by its sculptural remains. This 'heroic' image was substantially amplified by Fiocco and Longhi. The former brought out the strong impact of Tuscan artists on the art of Padua, a city already wide open to Renaissance influences since the fourteenth-century flowering around and after Giotto, with Menabuoi, Guariento and Altichiero. During the first decades of the fifteenth century there were in Padua such patrons as Palla Strozzi, such painters as Filippo Lippi, Paolo Uccello and Dello Delli, and last but not least the sculptor Donatello. A remarkable cultural environment, strengthened by a University, promoted learning and fostered intellectual curiosity in the city. Humanists and enlightened collectors, philosophers and writers, musicians and poets — all had pronounced classical leanings, which ran parallel to those of their Florentine counterparts. In brief, Mantegna's Padua was well prepared to absorb what Tuscany now offered, to elaborate, through its greatest artist, its own interpretation of the Renaissance, and to transmit it not only to the Bellini in Venice, but also to Tura, Cossa and De Roberti in Ferrara, to Costa, Francia and Correggio in Emilia, to Foppa in Lombardy, and to artists in Verona and the Marche. But this was a 'Venetian' Renaissance — not opposed to, but certainly different from, that of the Tuscans, and particularly well equipped, with its pervasive Late Roman and Byzantine heritage, for recovering the classical aesthetic, though more in terms of colour than of naturalistic design. All this was later to constitute the difference between Venetian and Florentine painting and to culminate in the sixteenth century in the contrast between Titian and Michelangelo.

Longhi's most original contribution to this topic also took for its starting-point the Venetian character of the Paduan Renaissance. But he laid great stress on the capricious, almost revolutionary temper — ranging from the unconventional to the disreputable — of the young artists who were prominent in the workshop of Francesco Squarcione. The latter was, according to Longhi, a kind of exorcist, who had gathered 'a band of desperate vagabonds, sons of tailors, barbers, cobblers and peasants . . . a workshop defying description or to be imagined only in a picture from the hand of some De Chirico — a twilight scene fraught with menace, where headless ancient busts support spiral frames ready to receive triptychs made to measure for the bishops of the Po delta; Florentine plaques serve as trays for ounces of the finest blue paint, Chinese rugs with ferocious monsters lie next to rolls of moth-eaten rags thrown away by Squarcione, *sartor et recamator*; and some "Western" miniature on an easel stands like a miracle next to a piece of Tuscan foreshortening "as an isometric figure" or to a crested coat of arms painted for some pretentious country squire. Recent sculpture casts lie here and there with white dust adhering to their milky surfaces, and all day long the riotous and mocking workmen of Donatello keep dropping in.'

Longhi's evocative vision stood in polemical contrast to the more traditional, less fanciful view that had held the field from the time of the studies of Kristeller (1901) and Adolfo Venturi (1914) until Fiocco. But it is undeniable that in the documents published by Lazzarini in 1908 and Erice Rigoni in 1928 Squarcione emerges as a

gifted middleman, *sartus ac recamator* by profession, and working but rarely as a painter. His greatest success lay probably in attracting and exploiting gifted young artists — particularly Mantegna during five years, but later also Zoppo and Schiavone, and perhaps Crivelli and Tura — whom he employed without wages to paint and to keep house for him. What is worse, he taught them little or nothing, yet dressed himself up in peacock's feathers as if he were a great master: '*Io ho facto uno homo Andrea Mantegna.*' But one disappointed pupil, Angelo di Silvestro, said in evidence: '*non ha maj insegnià ne mostra neanche el sa far per nissuno modo cum lavoreria ne cum alguna raxon le cosse chel promesse. . . .*'

It is clear from the documents that Squarcione was an interfering busybody who meddled in many artistic matters as expert or mediator. That was probably his principal activity, and he was much less competent as painter and teacher. It has long been debated whether he was an important factor in Mantegna's development or merely a middleman and 'expert'. It seems that the second view, which Fiocco always advocated emphatically, has at last gained acceptance. Recent studies have reassessed this curious and interesting personality, who collected casts after the antique and engravings by Pollaiuolo, but whose artistic merit was very slight: it was the young Tuscan masters visiting Padua and Venice who influenced the course of Paduan painting and particularly the development of Mantegna himself.

One man who certainly did have great importance for Paduan art was the painter and sculptor Niccolò Pizzolo (perhaps so named because of his short build), who had been known to Mantegna scholarship for a long time, but whose role was greatly clarified by Erice Rigoni in 1948 and by the critical investigations of Fiocco. His family came from Vicenza, and Pizzolo himself, who was born about 1420, led a rather dissolute life. Documents tell us that he fell foul of the police, perhaps in 1438, when he was found carrying arms at night outside Casa Sanguinacci. He was thrown into jail and tortured to extract a confession. Clearly he was not easy to get on with. We are also told of a quarrel in which he was involved in 1448: he had thought it expedient to hand over an apprentice to the painter Francesco dei Bazalieri, but later decided that he wanted him back; when Francesco refused, Pizzolo heaped abuse on the poor man and ended by saying: '*ipse Franciscus nescit pingere nisi laboreria grossa.*'

In the meantime Pizzolo had acquired a high reputation as sculptor and painter. First he worked as assistant to Filippo Lippi, then, in 1446-8, he worked with Donatello on the altar of the Santo, and finally, in 1448, he received the important commission for the Ovetari Chapel. Besides, the young Luca di Puglia applied to him in the same year for instruction in painting '*in recenti*', that is, in the style of those Tuscan artists with whom Pizzolo was familiar. We know also that there were paintings by him in his house, Le Torreselle, and in the house of Paolo Grassetto in the district of Rudena. Unfortunately Pizzolo's quarrelsome temper brought him to an early end. In 1453 he was badly wounded in a brawl and died shortly afterwards. His widow, Maria, inherited his possessions.

Pizzolo was Mantegna's colleague in the Ovetari Chapel from the beginning of the work in 1448. His decisive importance for the younger man's development had already been pointed out by Fiocco and has again been underlined by more recent writers. Indeed, both documentary evidence and an examination of the Eremitani frescoes

leave no doubt that it was Pizzolo who was the true, essential link between the art of Tuscany and the art of Padua, particularly through the connections with the sculpture of Donatello and the pictorial style of Filippo Lippi and Paolo Uccello (as represented in the lost frescoes of *Giants* of 1445 in Casa Vitaliani). Here we have undoubted points of similarity with Mantegna himself, who was at least ten years younger than Pizzolo. But these cannot have been the only influences on Mantegna, for the origins of his art were much more complex and his personality much more profound and sensitive. In any event, modern scholarship has followed Fiocco and has gradually come to the conclusion that Mantegna was trained not by Squarcione but by Pizzolo. At the same time his artistic formation was also conditioned by what Venice had to offer: he must have seen Castagno's frescoes of 1442 in the Tarasio Chapel of S. Zaccaria, and perhaps also Castagno's cartoon for the *Death of the Virgin* in the Mascoli Chapel of S. Marco. He was also greatly influenced by the painterly and colourful work of Filippo Lippi which he could see in Padua, as well as by Venetian masters from Jacopo to Giovanni Bellini. (In 1454 he married Jacopo's sister Nicolosia.) A visit to Ferrara in 1449 gave him an opportunity of seeing the limpid spatial harmonies of Piero della Francesca, who had been working among the 'delights' of the Este palace. On that occasion Mantegna may have noticed the harsh, realistic style of Rogier van der Weyden, who had passed through Ferrara on his way to Rome. But it seems to me plausible that he was also acquainted with monumental fresco schemes which were rather different from Giotto's classic work in Padua — I mean those which had recently been completed in the Sala del Maggior Consiglio of the Ducal Palace in Venice by Gentile da Fabriano, Pisanello and perhaps Jacopo Bellini. And as it is not impossible that, at the suggestion of his painter friends, he also visited Florence, he may well have admired Masaccio's frescoes in S. Maria del Carmine, of which one is irresistibly reminded, however great the differences, by the grandiose, heroic, powerful solemnity of the *Martyrdom* scenes in the Ovetari Chapel.

However that may be, there is no denying that the Eremitani frescoes are not only Mantegna's earliest surviving work (his polyptych for the church of S. Sofia having been lost), but also his greatest masterpiece, matched only by the later decoration of the Camera degli Sposi in the Palazzo Ducale at Mantua. As Fiocco points out in the following essay, Mantegna worked in the Ovetari Chapel for almost a decade: from the youthful age of seventeen until he became a mature artist. It is for this reason that the *Legends of St. James and St. Christopher* (apart from the scenes painted by his associates) were and still are — if only, for the most part, in mere reproductions — the evidence from which we must judge the personality of Mantegna as the pioneer of Renaissance painting in northern Italy. Let me therefore summarize our knowledge of the frescoes in the light of recent discoveries, some of them made since Fiocco's text was first published.

The nobleman Antonio Ovetari — a well-known patron of the arts, who had paid for a reliquary of St. Anthony in the church of the Santo — made a will on 5 January 1443, in which he left real estate to the value of 700 gold ducats to defray the cost of decorating his family's chapel, which already existed at the Eremitani. The frescoes were to depict scenes from the lives of the patron Saints, James and Christopher. The painters who were to carry out the work are named in a contract signed five

years later, on 16 March 1448, by Ovetari's widow, Imperatrice: they were Giovanni d'Alemagna and Antonio Vivarini from Murano and Niccolò Pizzolo and Andrea Mantegna from Padua.

Lionello Puppi has set out the reasons (which Fiocco had already hinted at in the essay below) why these two workshops and these particular subjects were chosen. The choice was obviously made on the advice of Ovetari's executors, two well-known citizens of Padua, the jurist Francesco Capodilista and the businessman Francesco di San Lazzaro. The two former artists were apparently chosen as being reliable and steady workers of conservative outlook. Giovanni d'Alemagna (who is identical, according to Erice Rigoni, with a Hans von Ulm) had decorated the *cappelletta nuova* of the bishop's palace for Monsignor Pietro Donato in 1437 and had given satisfaction. Almost as if to balance that overcautious choice, the other team chosen were two 'young lions'. Pizzolo must have recommended himself by his recent collaboration with Donatello, and Mantegna by the altarpiece for S. Sofia and perhaps also by his apprenticeship in the well-known workshop of Squarcione. There were thus two artists in the Venetian tradition and two Paduans: perfectly matched, they represent in the Eremitani the vital artistic conjuncture in the Veneto at the dawn of the Renaissance.

Let us now turn to the division of labour. Giovanni d'Alemagna and Vivarini undertook, for a fee of 350 gold ducats, to complete by December 1450 the *Four Evangelists* on the vault of the crossing, the *Passion of Christ* on the internal wall of the triumphal arch, two *Saints* on the inner curve of the arch, a frieze on the outside of the arch, and lastly the *Scenes from the Legend of St. Christopher* on the right-hand wall. The remaining frescoes were to be painted by Pizzolo and Mantegna for the same fee and to be completed by the same date. Their subjects are not specified in the first contract, but they can be deduced from documents dated 27 September 1449 and 5 February 1454: *God the Father* and *Saints Peter, Paul, James and Christopher* on the vault of the apse, the four *Fathers of the Church* in the roundels below, the *Scenes from the Legend of St. James* on the left wall, the *Assumption of the Virgin* in the centre, two *Gigantic Heads* at the sides, the friezes on the arch of the apse, and lastly an altarpiece with terracotta reliefs.

Puppi has tried to trace the iconographic sources beyond the well-known passages in the Gospels, the *Golden Legend,* and the *Lives of the Saints* by Jacopo da Voragine. He has suggested illuminated manuscripts which Ovetari's executors may have provided, or even tableaux from Miracle Plays. This reference to stage performances seems to me convincing and to accord well with the supposition that Mantegna may have made a direct study of paintings that were strikingly theatrical in their compelling immediacy and intense pathos: the 'stories' decorating the Sala del Maggior Consiglio in Venice, and perhaps also the scenes depicted by Masaccio in S. Maria del Carmine and by Uccello in the Chiostro Verde in Florence, which he may well have seen, although no such visit is recorded in the documents.

The course of events was to bring about a radical change in the even-handed division of labour between the two teams as stipulated in the contract. Already in 1449 the first difficulties arose between Pizzolo and Mantegna, very probably because neither was very assiduous. Mantegna went off on a visit to Ferrara, and Pizzolo,

during that time, evidently did not get on with their common task. When the matter went to arbitration on 27 September 1449, an amicable settlement was proposed by Pietro Morosini of Venice, who subdivided the work between the two colleagues. After consulting various experts, among them Squarcione, he allocated to Pizzolo the completion of the sculptured altarpiece and the paintings in the apse (except for *Saints Peter, Paul and Christopher,* which Mantegna had already begun); Pizzolo was also to paint the right half of the arch and to complete the last fresco of St. James, i.e. the *Martyrdom.* Mantegna, in addition to the three figures in the apse, was to complete the decoration of the arch and the first five scenes of St. James. Very little had thus been done by late 1449: only the terracotta altarpiece and some of the spandrels in the apse. Moreover, the two Paduans had received more money than was due to them, and they had to guarantee to finish their work as quickly as possible.

Nothing is known about the progress made by the two Venetian artists in the crossing, and it can be assumed that they had worked according to plan. But this part of the commission was also placed in jeopardy, for Giovanni d'Alemagna suddenly died in the spring of 1450. Imperatrice Ovetari immediately arranged for an inspection, with Squarcione and Pizzolo acting as experts, and it was found that the Venetians had worked only on the crossing and had neglected the triumphal arch and the right wall. In fact, Antonio Vivarini now proceeded to paint the four roundels of the *Evangelists,* but in November 1451 he withdrew from the enterprise and returned to Venice.

The documents published by Erice Rigoni in 1948 show that it was then decided to engage other painters to complete what the two Venetians had left undone. The replacements were Bono da Ferrara and Ansuino da Forlì, who received various payments in 1451. These payments refer doubtless to the two scenes in the middle register on the right, both of which are signed, *St. Christopher Carrying the Christ Child across the Ford* and *St. Christopher Preaching,* and very probably also to the two half-lunettes above. One of these, *St. Christopher Refusing to Serve the King of the Demons,* is almost certainly by Ansuino, while the other, *St. Christopher before the King,* has recently been shown by Puppi to be, as Longhi had suggested, the work of Gerolamo da Camerino. These three artists may have been recommended to the patrons by the ever active Squarcione, who remained behind the scenes as the confidant of Imperatrice.

The result of employing the substitutes was that the right-hand wall was largely finished in 1451. But we have no information about the bottom register (where Mantegna was later to paint the *Martyrdom of St. Christopher*) and none of the payments made in 1451 can readily be connected with this imposing fresco. It is true that some payments made to Mantegna in that year are recorded, but they amount to little more than 100 lire, and such a small amount is more likely to refer to the initial work on the *Scenes from the Legend of St. James* on the left-hand wall, namely the two half-lunettes, than to the *Martyrdom of St. Christopher,* which could have been left over for the time being.

With Antonio Vivarini having withdrawn towards the end of 1451, and Pizzolo not pulling his weight, Mantegna must have devoted himself to completing on his own the *Legend of St. James,* including the *Martyrdom,* which had been assigned to Pizzolo

in the arbitration of 1449. In the meantime Pizzolo seems to have gone back to his wild way of life, and in the spring of 1453 he died from wounds received in yet another brawl. All the work in the Ovetari Chapel now devolved upon Mantegna, and he was busily engaged on it during the remainder of that year and throughout 1454.

By 14 February 1454, when the paintings were valued by Pietro de Mazi, they seem to have been complete. In the apse Mantegna had painted the *Assumption of the Virgin* to take the place of the *Crucifixion* which Pizzolo had begun. The *Assumption* gave rise to a serious quarrel with Imperatrice Ovetari, who complained that Mantegna had painted only eight Apostles instead of the usual twelve. Fortunately for him, the expert who was called in, De Mazi, took his side and agreed that the space was not large enough for more figures. But Squarcione, as usual, took the contrary view and argued, like Imperatrice, that it would have been quite possible to include all the Apostles — if they had been painted a little smaller! Unfortunately we are not told what Mantegna replied, but it is easy enough to guess; nor is anything known about the outcome of the dispute.

The entire decoration must be assumed to have been finished in 1455, when the last payments were made. Some doubt remains with regard to the *Martyrdom of St. Christopher*: though there are no documents to confirm it, its attribution to Mantegna has never been called in question, but its date is very problematic and has provoked a lively controversy.

On the one hand there are those like Fiocco (and after him Paccagnini in 1965 and Romanini in 1966), who follow Vasari and believe that the chronology of the individual frescoes followed the 'logical' sequence of the scenes, in other words, that the two Paduans first completed the *Legend of St. James,* while the newcomers were working on the *Legend of St. Christopher,* until only the *Martyrdom of St. Christopher* remained to be painted. These scholars point for confirmation to Scardeone (1560) and Vasari (1568), who state that the *Martyrdom of St. Christopher* was the last fresco Mantegna painted and that he corrected a certain excessive hardness in the figures of the Saint so as to make the drawing and the colour more 'natural'.

The first writer to dispute the traditional chronology was Ragghianti in 1936, followed by Erica Tietze in 1955 and Pallucchini in 1956-7. They interpret the documents in the sense that, as the last payments were made in 1455, all the frescoes must by then have been completed. It follows, according to this thesis, that the *Martyrdom of St. Christopher,* which differs so strikingly from the *Legend of St. James* in its more naturalistic drawing and colouring, dates from an earlier stage in the artist's career and may have been painted in 1451. At least some part of the payments made in that year would have been for this fresco.

The last writer to contest this argument seems to have been Paccagnini (1965). After re-examining the payments recorded in the documents and drawing up a careful statement of account, he arrived at the conclusion that the fund of 700 gold ducats originally set aside for the entire commission had not been used up when the last payments were made in 1455. There was a balance left over, which could have been connected with the still uncompleted fresco of the *Martyrdom.* Since it would be absurd to assume that the executors would have made the final payment before the work was finished I think it is worth considering two other possibilities: either that Mantegna

had already completed the *Martyrdom of St. Christopher* and that the balance in the account represents some smaller payments made to the two Venetian artists who had not painted (nor did anyone else paint) the scene from the Passion on the triumphal arch; or else that it was planned to pay for the *Martyrdom* from an additional fund, which has not yet been traced in the archival records.

Puppi, too, thinks that the *Martyrdom of St. Christopher* was painted later. He dates it perhaps too late (1466-71), but he notes quite rightly that its 'different' style can better be accounted for by seeking links with Mantegna's later work than with early paintings which have not survived. Of the various dates suggested I think the most probable is the year 1455, i.e. just before the entire fresco scheme was completed. As we have seen, the accounts record the final settlement and there is no suggestion that any part of the work was still outstanding — which would be a strange omission in the case of such an important scene. Moreover, we know that just at that time, from 1455 to 1457, Imperatrice Ovetari was at odds with Mantegna on account of the missing Apostles in the *Assumption* and she would surely have blamed him also for failing to complete the *Martyrdom* (which could have been entrusted to no one else but him, as indeed it was) if in fact he had not already painted it.

While the *Martyrdom of St. Christopher* is certainly in some way the odd man out among Mantegna's frescoes in the Ovetari Chapel, it has in my opinion greater stylistic affinities with his later work, such as the S. Zeno altarpiece of 1459 in Verona, than with hypothetical and elusive works of his youth, which would necessarily have been close to the *Saints* in the apse. The softer colouring and a more naturalistic rendering of the landscape than in the *Legend of St. James* point in my opinion to the Venetian mode of the Bellini rather than to the Paduan legacy of Donatello and Uccello. And it should be borne in mind that in 1454 Mantegna had married Nicolosia Bellini and in the following year moved to Venice, before settling permanently in Verona and in Mantua.

This survey of the commission and of the results of recent researches can best be rounded off by a summary account of Mantegna's own frescoes in the light of what scholars have been able to add to Fiocco's perceptive and incisive discussion.

Mantegna's beginnings can doubtless be recognized in the apse spandrels of *Saints Peter, Paul and Christopher*, which he painted perhaps in 1449-50, when it became clear that Pizzolo would not do his allotted share. We have already mentioned that these grave, majestic figures reflect the Tuscan impact on Paduan art, through the work of Donatello as well as that of Filippo Lippi and Paolo Uccello, Modern critics have been right to stress that these *Saints* differ both from the coarse, jagged Gothic style of Squarcione and from Pizzolo's 'Paduan' idiom as seen in the *God the Father* of the fourth spandrel and in the foreshortened *Fathers of the Church* in the roundels of the apse. Mantegna's three figures are less angular and softer in outline, the chromatic range of the ground is less bright and has a more diffused colouring. He seems here to anticipate — perhaps also because he had already made his first visits to Venice and seen there the works of the Bellini and of Andrea del Castagno — that treatment of colour which was later to be frozen within an 'archaeological' composition, but which can always be distinguished from the lifeless tints and the unmistakable 'dabbing' brushstrokes of Pizzolo, who remained at heart always a sculptor rather than a painter.

The two half-lunettes, *The Calling of the Apostles James and John* and *St. James Speaking to the Demons*, probably paid for in 1451, show clearly enough that Mantegna's visit to Ferrara in 1449 had not failed to leave a mark. They recall the strained features and the expressive realism of Rogier van der Weyden, who had passed through the city in that year. Mantegna may have caught a glimpse of his work at the Este court and admired the frescoes that Piero della Francesca had recently painted there. These may account for a certain luminosity and the light colour scheme in the two half-lunettes. But at the same time Mantegna can hardly have been unaware of the examples of indigenous Paduan art constantly brought to his notice by Pizzolo. At that time Pizzolo was perhaps finishing the fine terracotta altarpiece and was painting, on the right-hand side of the triumphal arch, a *Gigantic Head*, which is difficult to interpret, but may be a self-portrait. The second *Gigantic Head*, in the corresponding position on the other side of the arch, has been more convincingly identified as a self-portrait of Mantegna. In any case, this head is an unforgettable image, not unlike a chiaroscuro woodcut engraved with a rounded chisel on a block, and alive with an artistic individuality which is matched in the late self-portrait bronze bust in S. Andrea in Mantua (as Fiocco pointed out in 1947).

This intensity of plastic expression, these richly varied relief accents on the surface paint, which reveal the temperament both of an engraver and a sculptor, seem to me to mark the transition to the style of the four lower frescoes of St. James, which Mantegna painted soon afterwards, probably about 1454. Now, after Pizzolo's death, he could shake off his dependence on the sculptural forms of Donatello; drawing and outline became dominant. It has been truly said that in these four frescoes Mantegna achieved his personal style. He was now a 'polished north Italian humanist' and had transcended the aesthetic norms of his early years (Puppi).

What strikes the beholder here is the profusion of classical motifs. It seems nothing less than a museum catalogue and in fact some of the pieces depicted by Mantegna can be found on ancient monuments or identified in inventories of Paduan collections. Tamassia has suggested that Mantegna wished to record in paint the 'museum' of Squarcione's workshop. This view, which forms part of the old controversy about Squarcione, can be shown, according to Fiocco, to be mistaken. He identified the classical sources of Mantegna, ridding him once more of the shadow of his supposed teacher. It is more probable, as argued by Panofsky and Puppi, that Mantegna, himself a passionate collector and steeped in classical culture, found his archaeology in local Paduan sources. Among these have been identified two humanists, Giovanni Marcanova and Felice Feliciano, who accompanied him some years later, in 1464, to the archaeological sites along Lake Garda in search of ancient sculptures with reliefs and Latin inscriptions. Crowned with laurel wreaths, the three friends called each other by learned Latin names. So it is not far-fetched to think that Giovanni and Felice played some part in the sudden emergence of classical elements in the *Legend of St. James*. Nor is it surprising that in these frescoes nature is reduced to an 'ideal city' modelled mostly on classical finds; that Saints and soldiers are turned into stone in ideal perfection, resembling statues brought from a garden of antiquities; and that the feeling for the historical truth of the events persists within symbolist or abstract surroundings, where some idiosyncrasies of drawing and colour go beyond the range

of what can be regarded as lifelike. Within the strict perspective of an ideal city conforming to the canons of Alberti, Mantegna has placed figures of such solemn presence that one might think he had known the wall-paintings of Pompeii long before they were discovered. Look at those figures in *St. James Baptizing Hermogenes* which 'pierce' the pilasters of the portico: their plastic density is equalled only by the sculptural weight of the figures on the right, seen from the back, both marking out and filling in the perspective, which is emphasized by the marble paving. Or consider *St. James before Herod Agrippa* and appreciate the balancing function of the soldiers in Roman armour, silhouetted against a scenery of arches, half-columns and reliefs: how they push back and almost overwhelm the tiny figures that can be glimpsed in the distance. The Saint, his head sharply raised to face the judge, the soldier with the slim, sensitive face, seen from the front, and his sturdy, bulky counterpart, seen from the back, the fair-haired centurion at the left, whose face is stamped like a medal — they form a striking chain of immobile, yet taut figures, with all the penetrating, mysterious force of a surreal, sometimes even obsessive world. Even the fresco of *St. James Being Led to Martyrdom,* animated by compact figure groups, cannot escape this compulsive vision: here, too, the space seems to be that of an airless aquarium where the colours of submerged rocks or tropical fishes are refracted, mysteriously vibrating, by still water.

The *Martyrdom of St. James,* probably the last fresco of this wall, seems to be set in a natural landscape, stretching from the city to a sinister plain strewn with rocks and instruments of torture. But here as elsewhere the oppressive sky, louring and unreal as when an approaching thunderstorm distorts the outlines of all things, seems to extinguish, in pale blue and silver shadows, every spark of life lived according to nature. There is here a tireless search for a formal perfection that exists solely in the artist's own despairing dream. Bearing such considerations in mind, one cannot fail to appreciate an incident recounted by Scardeone: Squarcione, we are told, rebuked Mantegna for failing to make his figures lifelike and said he ought no longer to imitate 'Roman statues, which could only be modelled by shadows, but living men . . .'

As regards the *Martyrdom of St. Christopher,* this old polemic has been succeeded by recent arguments about its dating. I do not feel that its style falls so far outside the artistic range of which Mantegna was capable during his years in the Ovetari Chapel as to justify such heated controversy. In fact it seems to me now that, whether we date it to 1451 or, preferably, to 1455, we can recognize in it elements that accord — as well as some that do not — with his earlier and his later work. Here we find, undiluted, a tendency wholly characteristic of him: a compelling tendency to condense the elements of an image, going so far as to subordinate the naturalistic detail, yet without loss of graphic accuracy. Take for example certain framed images, such as the two windows with the prefect struck by an arrow and the curious spectators; or certain portraits, which seem endowed with the living features of real people and yet have the polished elegance of a medal or an ancient relief. Or take the architecture with its obvious reference to the 'real city' — at the left the tranquil campanile rising above the cloister, and at the right the bridge connecting the houses and dotted with heads of women wearing white kerchiefs. In the middle Mantegna has set his usual classical edifice with niches and cinerary urns, and a medley of motifs taken

from Leon Battista Alberti. And notice lastly how the array of classical reliefs in the *Martyrdom of St. Christopher* corresponds with those on the massive red stone arch in the *Assumption of the Virgin* — bridging the gap, as it were, between these two apparently so dissimilar pictures.

And so one must agree again with the view put forward and substantiated by Giuseppe Fiocco in all his writings, in particular the one now republished, that the Ovetari frescoes, created by Mantegna between the ages of seventeen and twenty-five, consitute a coherent whole, and an almost miraculous achievement.

Terisio Pignatti

THE OVETARI CHAPEL

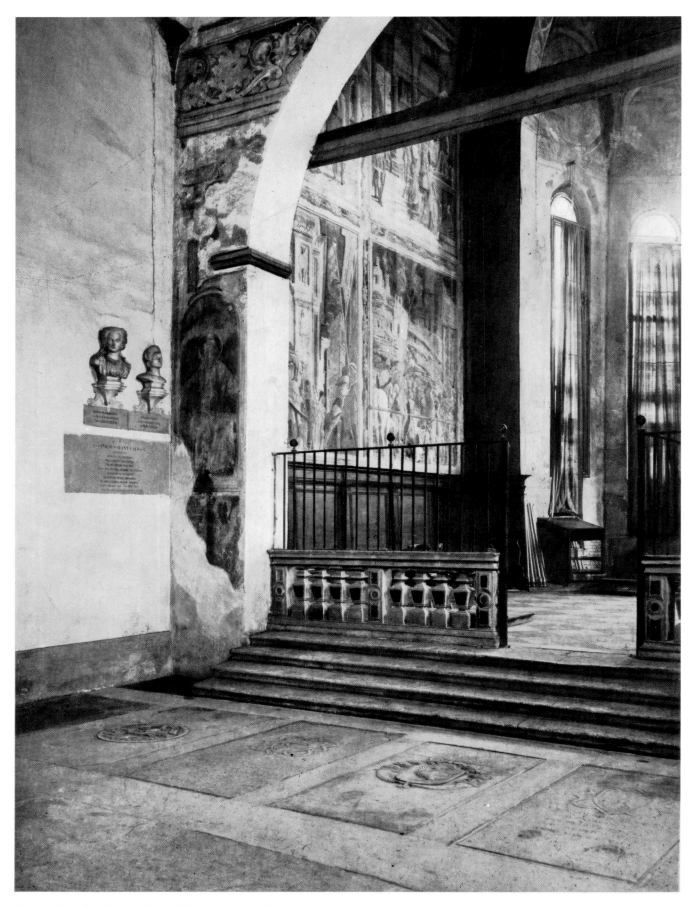

Fig. 1. The left wall of the Ovetari Chapel, seen from the antechapel.

Fig. 2. Antonio and Bartolomeo Vivarini and Giovanni d'Alemagna: Decoration on the vault of the Ovetari Chapel (Fig. 8, compartment D).

THE OVETARI CHAPEL AND ITS DECORATION

The architectural organization of an interior cannot fail to influence its painted decoration: the visual rhythm of the paintings matches the rhythm of the wall surfaces, and this determines the way in which the artist separates or links his compositions and treats light and space. We must therefore devote a few words to the construction of the Ovetari Chapel, which contained the first major work of Andrea Mantegna. During the first half of the fifteenth century a Paduan notary, Antonio Ovetari, had the chapel completely rebuilt and in 1443 and 1446 he bequeathed the sum of 700 ducats to defray the cost of decorating it with frescoes depicting the legends of St. James the Greater and St. Christopher. In the past these saints have often been mistaken for the patron saints of the Eremitani Church, with which the chapel makes such a harmonious whole.

At the right of the church nave is a kind of atrium, not unlike the arm of a transept, and from here a few steps lead to the chapel itself (Fig. 1). The chapel is a rectangular room, Gothic in character, and has a vault with crossed ribs; a triumphal arch separates it from a five-sided apse with five ceiling spandrels, which taper towards the triumphal arch (Fig. 15).

This room was intended to be decorated with frescoes, and indeed much of it was.

[19]

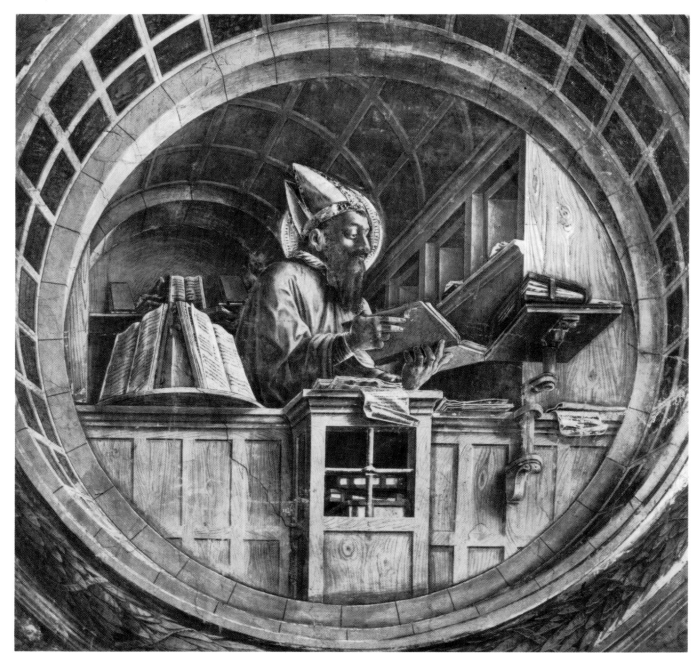

Fig. 3 Niccolò Pizzolo: *A Father of the Church*. Apse of the Chapel (Fig. 8, compartment H2).

On 16 May 1448 the donor's widow, Imperatrice Ovetari, made an agreement with two teams of painters, one headed by Niccolò Pizzolo and Andrea Mantegna, the other by Antonio Vivarini and Giovanni d'Alemagna. This choice meant that artists interested in stylistic innovation were to work side by side with upholders of tradition, and indeed the intention may have been to encourage rivalry and competition. Each group was to carry out one half of the projected scheme, and each was to receive one half of the 700 ducats. But eventually nearly the whole of it went to the "modern" team, for Giovanni d'Alemagna died in 1450 and Antonio Vivarini used this as a pretext for withdrawing after hurriedly decorating the vault of the chapel with roundels of the four Evangelists (Fig. 2). It is even possible that these were carried out by his younger brother Bartolomeo, who had succeeded Giovanni as his collaborator and

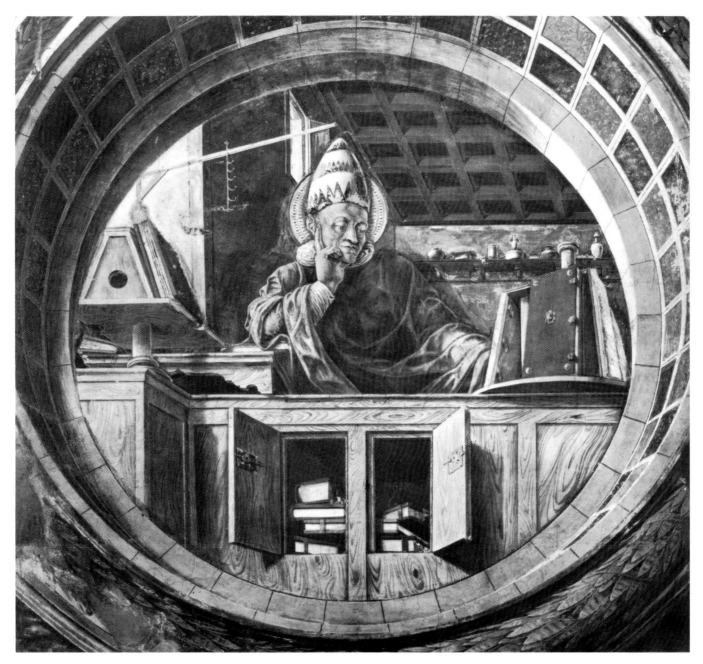

Fig. 4 Niccolò Pizzolo: *A Father of the Church*. Apse of the Chapel (Fig. 8, compartment H3).

who was already experimenting with the stylistic discoveries of the Renaissance. But the luxuriant surrounds, while they are in the new idiom, are still Gothic in spirit: the artist does not conceal his delight in festoons stretched like lace across the bright-blue ground or in angels posed awkwardly like puppets stuffed with straw.

The style which the young Paduans, Pizzolo and Mantegna, had brought to their task in the chapel was so vivid and novel that no other artists were called in to compete with them after the older team had dropped out. The whole task now fell on their shoulders, except the decoration of the vault, which, as mentioned above, had already been completed. But one part of the projected scheme was never carried out: a large Crucifixion which Antonio Vivarini and Giovanni d'Alemagna had undertaken to paint above the entrance door of the chapel.

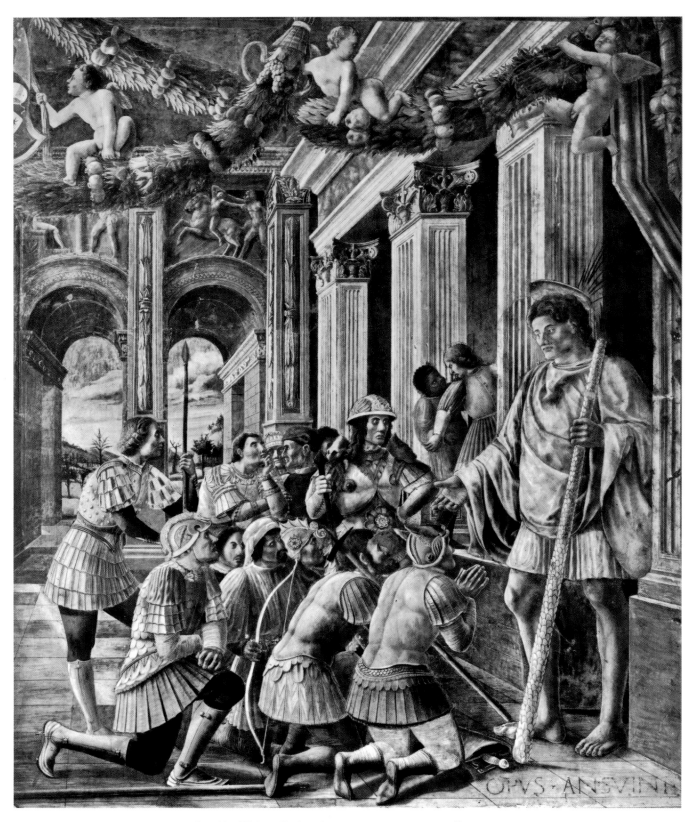

Fig. 5 Ansuino da Forlì: *St. Christopher Preaching*. Right wall of the Chapel (Fig. 8, compartment S).

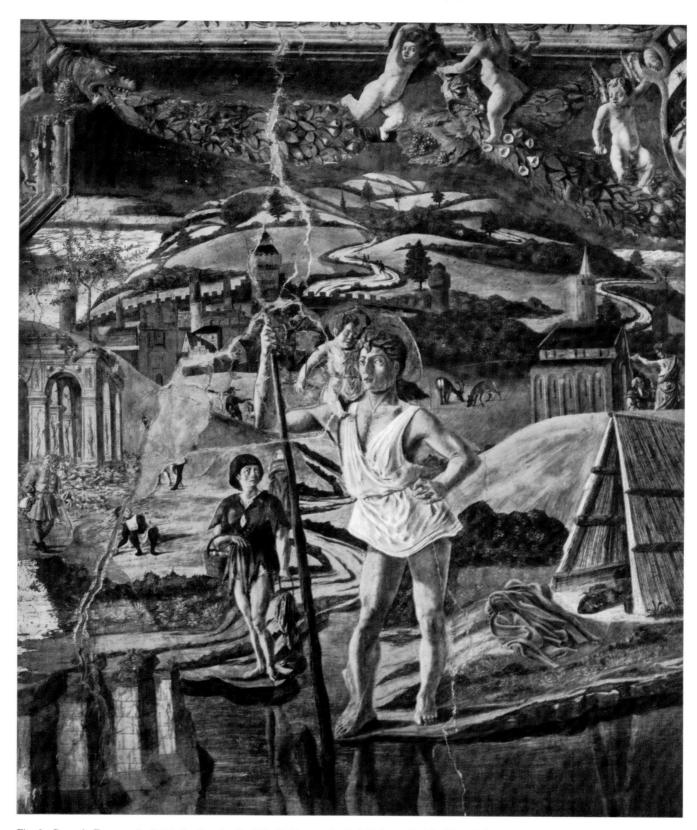

Fig. 6 Bono da Ferrara: *St. Christopher Carrying the Christ Child across the Ford.* Right wall of the Chapel (Fig. 8, compartment R).

The close stylistic affinity between Pizzolo and the young Mantegna long gave rise to doubts as to which of the paintings in the chapel were to be assigned to each master. The documents published by V. Lazzarini and Erice Rigoni have at last settled this question. One of these documents, an arbitration of 27 September 1449, also proves beyond doubt that it was not Francesco Squarcione, the overrated native founder of the Paduan Renaissance school, but Niccolò Pizzolo, who deserves the credit for the artistic formation of his great colleague Mantegna.

Pizzolo was born about 1420 and met an untimely death in a brawl on 18 December 1453. Reliable evidence associates him with Fra Filippo Lippi and with the paintings which the latter had carried out in the Palazzo del Podestà in Padua shortly before 1437. He was, in fact, the undoubted link with those Tuscan artists to whom the Venetian Republic had been shrewd enough to give employment: Niccolò Lamberti had arrived in 1413 with his son Piero; he was followed by Paolo Uccello in 1425 and Andrea del Castagno in 1442. This connection explains the direction that Venetian art was taking and why it first developed, not in Venice itself, but in Padua. It was here, in the work of Mantegna, that the early Tuscan Renaissance found its fullest realization, and as a result Padua became the centre of the artistic revival of northern Italy. Now that we know from documents that the figures of Saints Peter, Paul and Christopher on the ceiling of the apse are the work of Mantegna, whereas those of St. James and God the Father (Figs. 14 and 15), while very close in style, were painted by Pizzolo, we can clearly identify and understand the origins of the Paduan school of painting.

Pizzolo had also undertaken to decorate the strip of wall just below the ceiling of the apse. Here he painted four perspective roundels depicting the Fathers of the Church, each seated in his study (Figs. 3 and 4), to correspond with the circular window in the centre of the strip. These beautiful roundels must have made a strong impression upon the rising star, Mantegna, as well as upon contemporary Ferrarese painters, to whom they have sometimes been attributed. Pizzolo also made the terracotta altarpiece with a relief of the *Virgin and Child with Saints* (Fig. 7), an invention derived from Donatello's altar in the Santo. Donatello had been at work in Padua since 1443, and Pizzolo had assisted him with the bronzes for the Santo in 1446-7. Pizzolo also painted the angels on the left underside of the arch and the gigantic head on the right spring of the arch. But he did not live to finish the *Assumption of the Virgin* on the back wall of the apse nor the last scene from the legend of St. James, both of which then devolved upon Mantegna.

Mantegna's share had thus grown enormously, but he tackled it with the confidence of genius and with the help of competent assistants. That is how part of the legend of St. Christopher came to be painted by two artists who until recently were thought to have left us no other examples of their work.

The first artist called in to take part was Ansuino da Forlì, who signed the fresco facing Mantegna's *St. James Baptizing Hermogenes* on the opposite wall. It shows St. Christopher leaning on a staff and addressing his kneeling disciples (Fig. 5) and reveals clearly that Ansuino, like Pizzolo, had worked alongside Filippo Lippi in the Palazzo del Podestà.

But though Filippo's influence is evident in the figure types and in the light and limpid colouring, it is equally obvious how much Ansuino had already learnt from

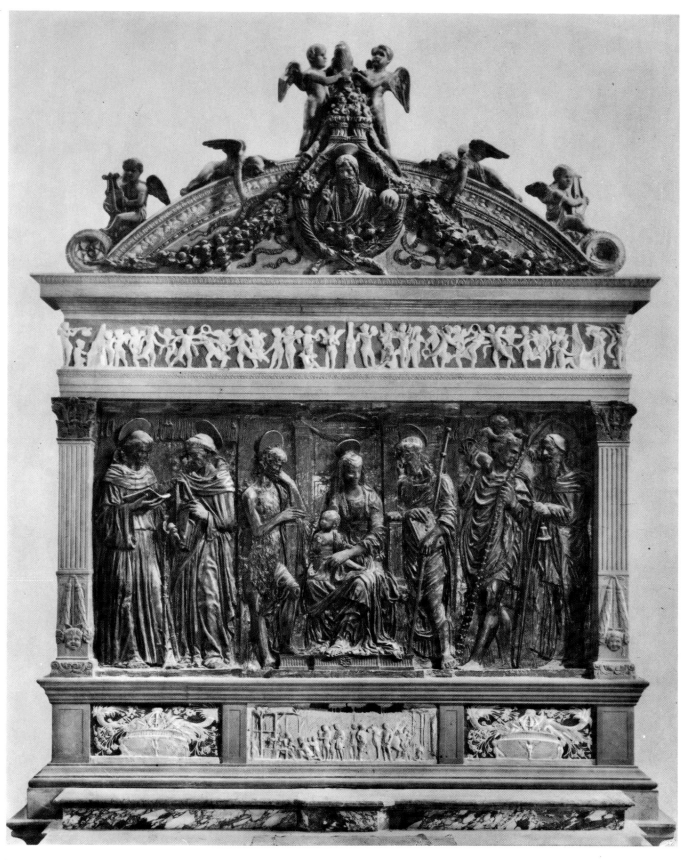

Fig. 7 Niccolò Pizzolo: *The Virgin and Child with Saints Anthony of Padua, Peter Martyr, John the Baptist, James the Greater, Christopher and Anthony Abbot;* (below) *The Adoration of the Magi.* Terracotta altarpiece in the Ovetari Chapel.

Mantegna. In comparison with the *St. Christopher Preaching*, the two half-lunettes above, depicting *St. Christopher before the King** and *St. Christopher Refusing to Serve the King of the Demons*, are certainly much tamer, for here Ansuino was still directly dependent on Filippo Lippi — a dependence that must have accorded with his taste and artistic limitations — and had not yet been able to benefit from the bolder work of Mantegna. That is why the attribution to Ansuino, whose influence must later have helped to launch his compatriot Melozzo, has been doubted by some writers, although it goes back to so early a source as Marcantonio Michiel, the so-called Anonimo Morelliano. But it is quite mistaken to think of Giovanni Boccati, whose style was entirely different and who is not known to have visited Padua.

The fresco of *St. Christopher Carrying the Christ Child across the Ford* (Fig. 6) was painted, and also signed in capital letters, by Bono da Ferrara. His style presents no problems: based on a quite simple distribution of large masses, both in the landscape and in the figures, it is clearly indebted to Piero della Francesca. But a loving attention to detail and the charming motif of the two grazing fawns betray, behind the inspiring influence of Piero, the artist's training in the International Gothic style. Yet though he was, like Francesco Cossa, a typical member of the Ferrarese Quattrocento school, and attracted by the simple, abstract idiom of Piero, his impressive fresco in the Ovetari Chapel must not lead us to reject or ignore a group of youthful works, in the International Gothic taste, which owe much to the influence that Pisanello and Jacopo Bellini had on the courtly art of Ferrara. Bono's panel of *St. Jerome* in London, which is also signed and which proves him to have been a pupil of Pisanello, must not be rejected in spite of a slightly incorrect inscription. There is no justification for attributing it to Pisanello himself, and the two grazing fawns, a motif serving also as a signature, reappear in the fresco at Padua. Based on that panel, I have identified a group of Bono's early pictures. Tancred Borenius has since added two further works, in which forms derived from Piero della Francesca are still combined with the arabesque backgrounds of French book-illumination and which form the bridge to the artist's mature style — the style of his fresco in Padua.

The Ovetari Chapel thus has a twofold importance: containing Mantegna's earliest works, painted between 1448 and 1455 or perhaps 1457, it gives us an insight into his artistic formation and aims; but it also helps us to understand the development of Paduan painting in the fifteenth century, and through it the triumph of the Renaissance in the Venetian territories and in northern Italy. Its destruction was one of the most grievous losses that the tangible patrimony of human genius has suffered. But its spiritual value is perennial, and in devoting these few pages to it we are dealing with the greatest victory of the Tuscan Renaissance — its conquest of the Veneto. Here the mastery of form understood as volume, and of pictorial space as ordered by the laws of geometry, was extended beyond scientific preoccupation: form was transformed, and tamed, by means of colour, and linear perspective by means of aerial perspective. And so modern art was born.

*According to Pignatti (see p. 10), this fresco is now known to be by Gerolamo da Camerino.

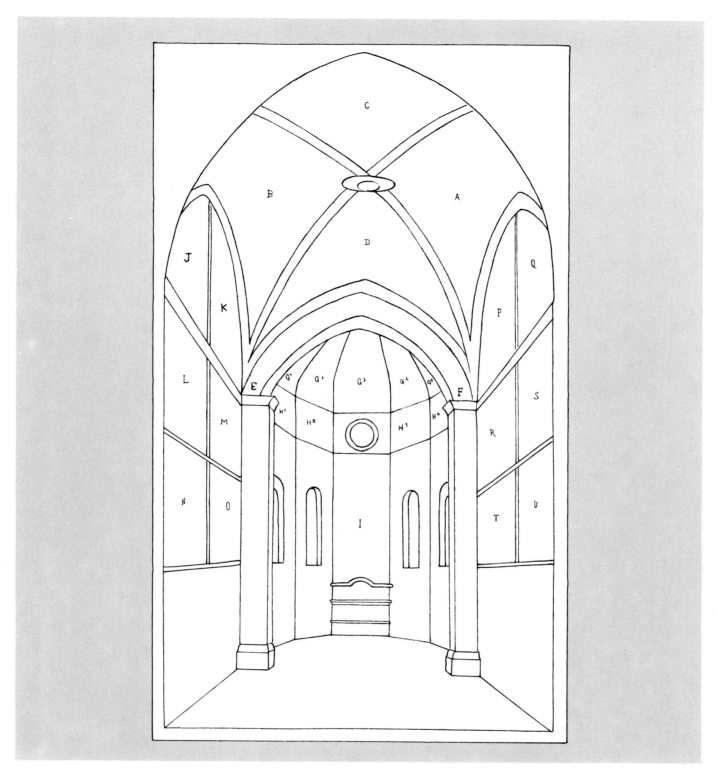

Fig. 8. Diagram of the fresco decorations in the Ovetari Chapel.

A-D. Antonio and Bartolomeo Vivarini and Giovanni d'Alemagna: Vault decorations. See Fig. 2.
E. Mantegna: *Self-Portrait* (?). See Fig. 9.
F. Niccolò Pizzolo: *Gigantic head.*
G1. Niccolò Pizzolo: *God the Father.* See Fig. 14.
G2. Mantegna: *St. Peter.* See Fig. 15.
G3. Niccolò Pizzolo: *St. James.*
G4. Mantegna: *St. Paul.* See Fig. 14.
G5. Mantegna: *St. Christopher.* See Fig. 15.
H1-H4. Niccolò Pizzolo: *Fathers of the Church.* See Figs. 3 and 4.
I. Mantegna: *The Assumption of the Virgin.* See Plates I and II.
J. Mantegna: *The Calling of the Apostles James and John.* See Figs. 10 and 16.
K. Mantegna: *St. James Speaking to the Demons Sent against him by the Magician Hermogenes.* See Figs. 11 and 16.
L. Mantegna: *St. James Baptizing Hermogenes.* See Fig. 16 and Plates III-VI.

M. Mantegna: *St. James before Herod Agrippa.* See Fig. 16 and Plates VII-IX.
N. Mantegna: *St. James Being Led to Martyrdom.* See Fig. 16 and Plates X and XI.
O. Mantegna: *The Martyrdom of St. James.* See Fig. 16 and Plates XII-XVI.
P. Gerolamo da Camerino (formerly attributed to Ansuino da Forlì): *St. Christopher before the King.* See Fig. 17.
Q. Ansuino da Forlì: *St. Christopher Refusing to Serve the King of the Demons.* See Fig. 17.
R. Bono da Ferrara: *St. Christopher Carrying the Christ Child across the Ford.* See Figs. 6 and 17.
S. Ansuino da Forlì: *St. Christopher Preaching.* See Figs. 5 and 17.
T. Mantegna: *Archers Shooting at St. Christopher.* See Fig. 17 and Plates XVII-XX.
U. Mantegna: *St. Christopher's Body Being Dragged away after his Beheading.* See Fig. 17 and Plates XVII and XXI-XXV.

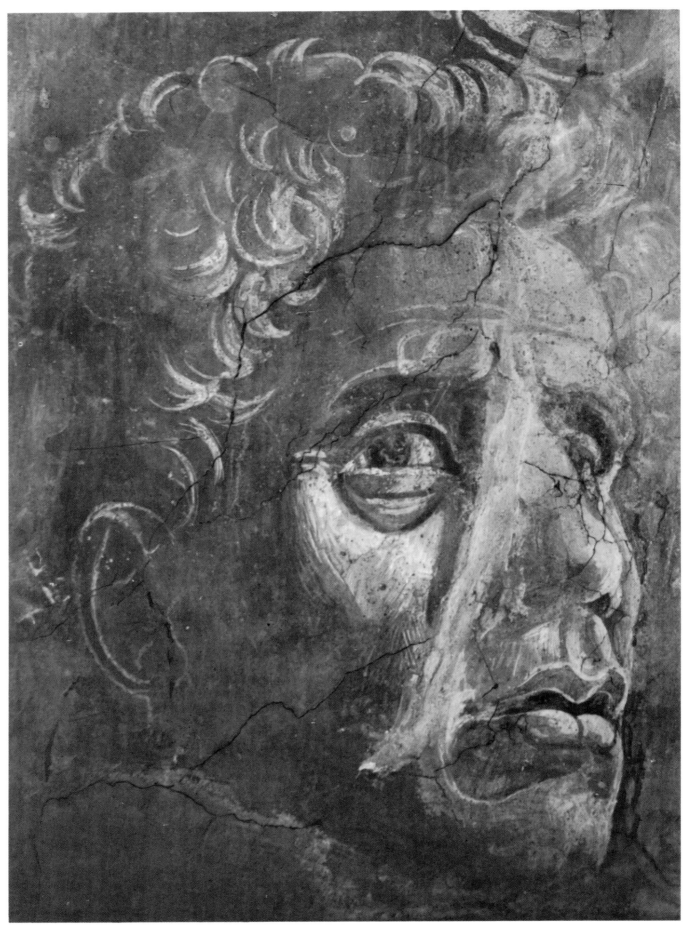

Fig. 9. Mantegna: *Self-Portrait* (?). Left side of the arch (Fig. 8, compartment E).

THE FRESCOES OF MANTEGNA

This brings us to the standard-bearer of this great battle, the champion of the *stil nuovo* of the Renaissance. He was to become its noblest and fullest voice, for the poetry of his time produced nothing that could match the triumphs won by the fine arts. Everything else is mere prelude or trivial incident, compared to the luminous beauty with which he filled the Ovetari Chapel. It was here that he stepped into the limelight, still a youngster, and became a man and an artist at the same time. Here his powers matured; here his genius found full scope in a triumphant achievement.

When he joined Pizzolo in this undertaking, Mantegna was barely seventeen years old. He was born in 1431 at Isola di Cartura, 20 km. north of Padua, the son of a carpenter named Biagio. The documents tell us that he was adopted by the Paduan painter Francesco Squarcione and served his apprenticeship in the painters' guild from 6 November 1441 until 1445; that by 6 January 1448 he had left his teacher's workshop and set up on his own account; and that on 16 May of that eventful year, after he had taken on the commission in the Ovetari Chapel, he was paid for an altarpiece which he had painted for the church of S. Sofia. This picture has disappeared, and thus it was only in the Ovetari Chapel that his early work — he was still little more than a boy — could be seen.

Pizzolo must have been the dominant partner in the work jointly entrusted to him and Mantegna: not only was he the older man, but he would have been entitled to respect from one whom he had chosen as his associate. Unfortunately he did not profit greatly from the partnership, nor did it last long, for he died at an early age in 1453. But as he reserved for himself the centre wall of the apse, which was not only the largest, but also the most conspicuous of the surfaces to be decorated, his taste must have had a commanding influence: ribbons scattered profusely all over the spandrels and lavish festoons suspended like canopies over the figures of the entire vault — such Gothic pomp was what appealed to Pizzolo, as we can also see in the lunette of his terracotta altarpiece (Fig. 7). Even if such embellishments were not quite alien to Mantegna we must assume that he merely acquiesced, imitating them reluctantly and not as a matter of preference. If Pizzolo delighted in weaving his ribbons and garlands with great ingenuity round his representation of God the Father, Mantegna in his companion spandrels with Saints Peter, Paul and Christopher added them obediently rather than spontaneously (Figs. 14 and 15).

But his three figures are so close in style to the one by Pizzolo that we should still be arguing about their authorship if it had not been established by a recently discovered document. Even now we cannot shake off the impression that in these calm figures, especially Peter and Paul, the artist's hand betrays a certain timidity, which is not, however, without dignity. This dignity, this very personal way of feeling, already manifests itself at the outset of the young master's career. So does the exquisite delicacy of his technique, and the air of majesty with which he was soon to endow his figures when he gave them a gentler and less forbidding expression. Even the sturdy, impressive figure of St. Christopher (Fig. 14) looks up with a keen gaze that is

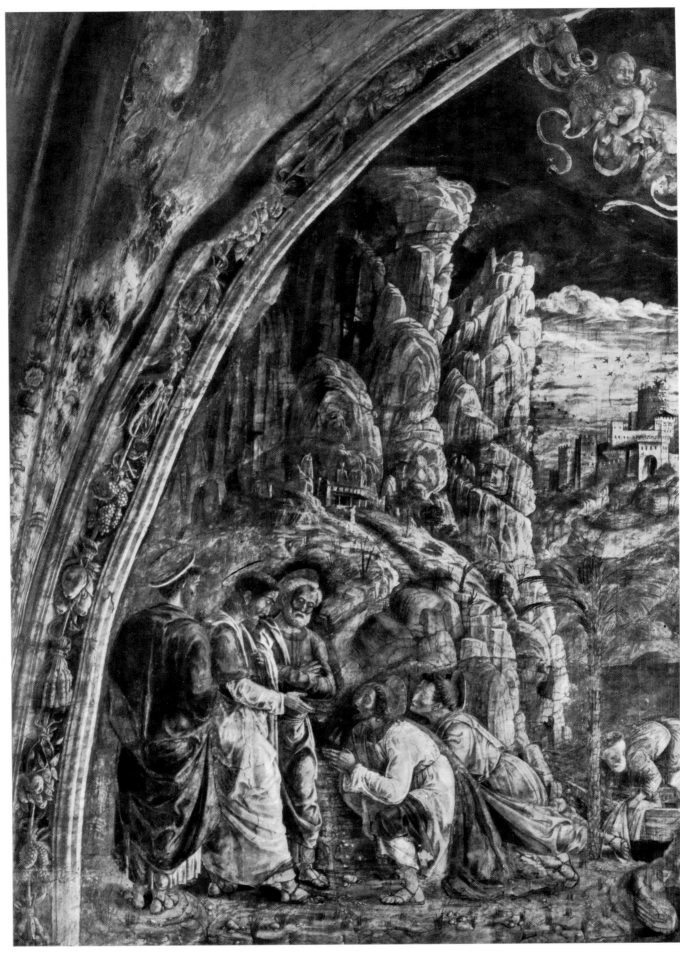

Fig. 10. Mantegna: *The Calling of the Apostles James and John*. Left wall of the Chapel (Fig. 8, compartment J).

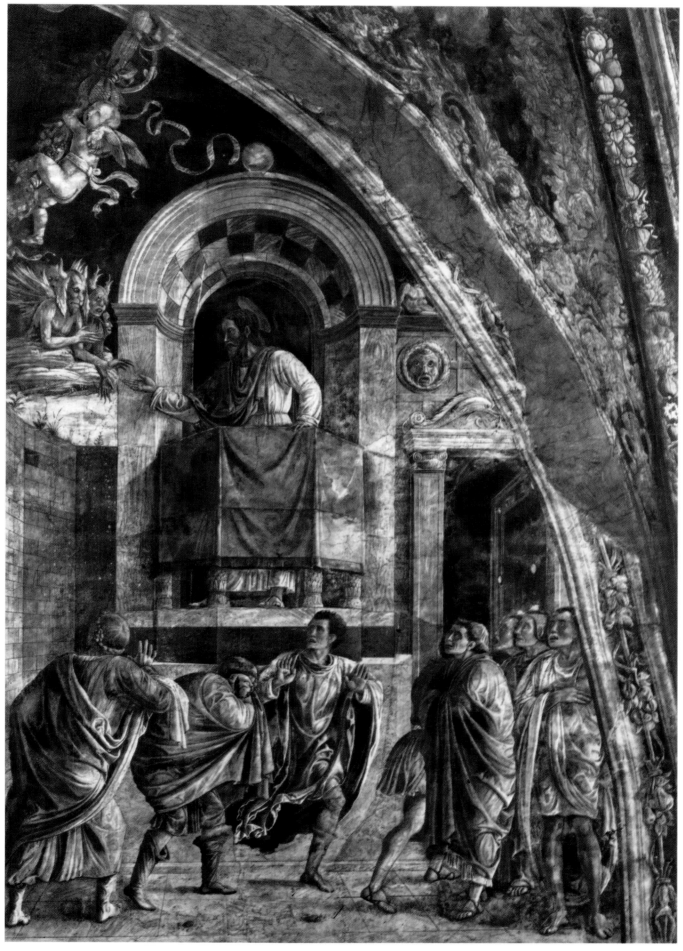

Fig. 11. Mantegna: *St. James Speaking to the Demons Sent against him by the Magician Hermogenes*. Left wall of the Chapel (Fig. 8, compartment K).

intense and severe, but not troubled. It recalls Andrea del Castagno, and there is in fact no other painting so reminiscent of the marvellous frescoes of the Evangelists that Castagno had painted in 1442 in the church of S. Zaccaria in Venice.

Although we are no longer in doubt which of the frescoes were painted by Mantegna and which by Pizzolo, the documents throw no light on their chronology, and here we are still dependent on stylistic analysis. Later on, when Mantegna was working on his own he could move more freely. As long as the rest of the apse remained Pizzolo's responsibility, Mantegna, having finished his three ceiling spandrels, must at once have begun the lunette with the first two scenes from the legend of St. James, while Pizzolo was to work on the Assumption.

Here the young master tackled not just one composition, but a pair: beginning at the left with the *Calling of the Apostles James and John* (Fig. 10), balanced by the scene of *St. James Speaking to the Demons* (Fig. 11). Which of the two scenes he painted first we do not know, but I believe that he followed the order of the narrative, since in the left-hand scene the colours are more muddy — one might almost say, jaded, and the festoons of fruits and plants strung out along the borders still have a heaviness which was later to disappear. Before a grandiose background of towering rock formations Christ stands between the Apostles Peter and Andrew. The fishermen James and John are kneeling before him, while their father Zebedee busies himself in the boat. There is nothing oblique or symbolic in the way the artist depicts the subject — he lets the event speak for itself. It is as if he wanted to match the seriousness of the encounter with the harshness of nature: the Dolomitic rocks rise up precipitously like steeples and their varied striations are carefully rendered. Such geological accuracy was to recur throughout his later work. Even though the whole has something turbid about it, the young artist was already able to give us, not Ansuino's ill-defined mountain slopes, but nature observed in detail. The two kneeling figures, gazing devoutly up at Christ, are still reminiscent of those in the spandrels of the apse, but Christ himself and the two Apostles standing beside him have a singular majesty of bearing — the Apostle seen from the back, in particular, has been said by a perceptive nineteenth-century connoisseur to be worthy of Piero della Francesca. Their relaxed bearing and dense colours suggest that the painter had made a close study of Tuscan art, especially the works of Andrea del Castagno. Indeed, the similarities are so strong that it has long been in doubt which of the two masters supplied the design for the magnificent mosaic of the *Death of the Virgin* in the Mascoli Chapel of the basilica of S. Marco in Venice. It was probably once again at the prompting of Pizzolo that Mantegna added the knotted ribbons hanging across the two scenes; but he placed them so high as not to disturb the composition, and contented himself with one pair of putti.

The scene of *St. James Speaking to the Demons* in the right-hand half of the lunette (Fig. 11) seems calmer and more pellucid. There are early examples here of features that were to characterize Mantegna's work throughout his life: a preference for dry, lean bodies and a love of antique motifs, used not at random or out of place, but fully in keeping with the subject. Calmly addressing the demons, the Apostle stands behind a draped lectern on a pulpit. The arch with its hollow embrasure is a masterpiece of Renaissance imagination. The door at the right, however, is a fanciful invention made up of various classical elements: a dolphin over the lintel, a laurel wreath surrounding a

Medusa head without snakes, and on the top a fragment of a recumbent river-god. But none of this distracts attention from the action itself, in particular from the terror that the devilish apparition has aroused in the spectators, some of whom are fleeing while others stand rooted to the spot with staring eyes. The whole fresco is suffused with a light and limpid colouring that reveals the influence of Filippo Lippi.

It seems probable that after finishing these two scenes Mantegna interrupted his work in the Ovetari Chapel. He may have visited Ferrara, where he is known to have painted a double portrait for Lionello d'Este in 1449. Piero della Francesca was also working at the Este court at that time, but Mantegna, who had only just left the Gothic world behind him, was apparently even more strongly affected by the marked naturalism of another artist then active in Ferrara — Rogier van der Weyden, in whose work the expressive stops barely short of caricature. We can trace this inspiration in Mantegna's *Adoration of the Shepherds* in the Metropolitan Museum in New York, especially in the ragged peasants, who seem to grimace while they bow down — a group more reminiscent of Crivelli than of a moody and ecstatic artist like Cosimo Tura. However, the splendid lunette (now almost completely ruined) painted in 1452 over the main door of the Santo shows that Mantegna then returned to his former style, as do his works for Venice and the polyptych (now in the Brera, Milan) for the chapel of St. Luke in the church of S. Giustina. The work he did on his return to the Ovetari Chapel, where Pizzolo had in the meantime been working on his own, also bears this out.

Mantegna now painted the two scenes in the middle register of the left wall, beginning with the *St. James Baptizing Hermogenes* (Plates III-VI), where the rhythm and the arcade at the right clearly correspond with the scene directly opposite, *St. Christopher Preaching*. The Hermogenes fresco bears the stamp of a master of invention; but it also has a further significance. The elongated figures, the unobtrusive hints of a classical setting, the perfect clarity — all this is clear proof of a contact with Jacopo Bellini. It is only natural that Mantegna should have been attracted to an artist who had the keenest interest in everything that was new, and he was soon to be more closely linked to him by personal ties: in February 1454 he married Jacopo's daughter.

The stage is bounded by elegant marble architecture — at the left a receding colonnade topped by an architrave, and at the back an arcaded building with the Saint's shop, where bowls and pitchers are on display and two serving-men can be discerned in the shadows behind the counter. In the paved courtyard stands the principal group, which in some ways repeats and refines the group in the *Calling of James and John*. But the scene has more pathos than drama, the atmosphere has no tension and makes the gestures slack, the painter has contented himself with hints and enveloped the tall, graceful figures in a reverent, truly religious silence. Hermogenes has knelt down, his bell-shaped cloak spread over the pavement, and bows his noble, white-haired head under the water which the Apostle pours from a small ewer. James is half wrapped in a gown, which falls over his left arm; he is stretching out his right arm, and bending forward slightly. The bystanders, some of them in the courtyard, others between the pilasters of the portico and on a balcony, are dressed in contemporary fashion or in Oriental garb. The two graceful children in the foreground, the elder leaning against a pilaster, the younger, who has barely learnt to walk,

in a baby's pink frock and bonnet, could have come out of one of Jacopo Bellini's sketchbooks.

This domestic vignette is almost an echo of a nuptial song, of Mantegna's marriage into the Bellini family. In the adjoining fresco, where St. James stands before the judge's tribunal (Plates VII-IX), we enter quite a different world. Now the artist is fully steeped in the spirit of humanism — treating it not as an empty display, but comprehending it with a religious earnestness. What he offers us is the resurrection of an ancient world experienced, with mystical fervour, as a paradise to be reconquered.

The judge is seated on a podium in the attitude of an emperor. His throne, with sphinx-shaped arm-rests and a high back surmounted by a canopied baldachin, seems more suitable for a bishop than for a Roman tetrarch. Behind him stand two lictors or servants. A man of unassailable power, high on a marble dais, he is made to appear like a heathen idol. The majesty of the law rules among the soldiers, the Apostle's sole companions before the judgement seat, who guard the tribunal. He who wears the judge's toga is perhaps also a soldier, and owns the sword, shield and helmet guarded by the pensive page standing in the foreground like a statue, his head buried under a helmet much too large for him.

Judge and victim look straight at one another, both fearless, and the Saint accepts his sentence proudly. The guards seem uneasy, especially the one standing alone at the left. Some of the bystanders remain unconcerned outside the court, others look on mournfully, held back by the soldiery under a grandiose triumphal arch. Everything seems charged with a new energy, objects as well as men, an energy that is restrained and subdued, but present nonetheless, lying in ambush as it were. There are no theatrical gestures; in Mantegna's art gestures are sparing, but decisive. The judge, in whose expression sadness is mingled with severity, seems to anticipate the Caesar whom Mantegna was to paint more than thirty years later in the *Triumph* at Mantua (now at Hampton Court).

In the two frescoes of the bottom register virtuosity is superadded to art. And though they arouse even greater admiration, they do not now come as a surprise. The artist was now fairly obsessed with the Renaissance; it had penetrated him to the marrow. From now on his figures were no longer imitations of Roman statues, but men of flesh and blood, and to heighten the effect and the unexpectedness in the last two scenes he chose a low viewpoint. He had admired Paolo Uccello's recent frescoes of Giants in the nearby Palazzo Vitaliani, and in Ferrara he had known the master of the "Divina Proporzione", Piero della Francesca. So when the last compartments fell to his share after Pizzolo's death, he was eager to demonstrate that perspective could achieve much more than his older colleague had attempted. Naturally the result was nothing artificial, nothing that would have been mere bravura. He contented himself with a steeper foreshortening in the scene of *St. James Being Led to Martyrdom* (Plates X and XI), where the procession is held up by the jailer, who has knelt down to receive the faith from the Apostle. After walking down one of the medieval streets common in north Italian cities, lined with plain houses of various shapes, St. James has just passed under a grandiose arch. Among its reliefs is a plaque with the name of Vitruvius Cerdo, the architect who had built the Arco dei Gavi in Verona, but who was often confused with the famous ancient writer. It may well have been Mantegna's father-in-law, Jacopo

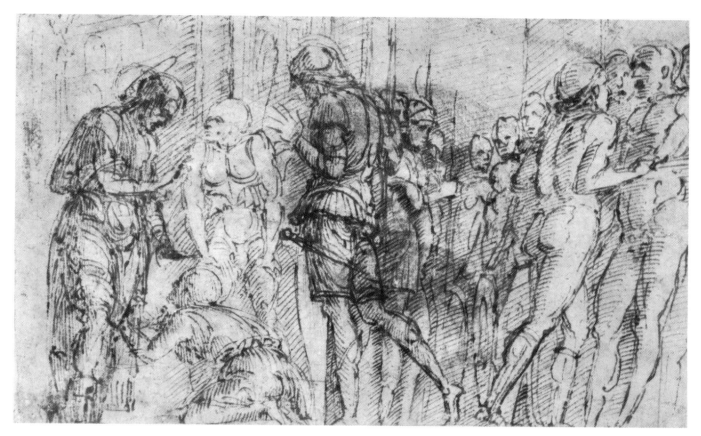

Fig. 12. Mantegna (?): *St. James Being Led to Martyrdom*. Pen drawing. (Cf. Plate X) London, British Museum.

Bellini, who suggested these archaeological features as well as the similar carved roundels and inscriptions in the previous fresco, written in elegant lapidary letters, though not without mistakes.

The composition is very powerful. The principal figures are placed on a low platform behind which a street runs into the distance; they and the other figures in the foreground stand out prominently. This is achieved not only by their spatial isolation, but also by the very markedly reduced size of those standing behind, who are made to appear even more distant through foreshortening. A pen drawing of the figures (Fig. 12) is in the British Museum (formerly in the Gathorne Hardy Collection at Donnington Priory). This sheet, sometimes attributed to Mantegna, is not, in fact, a preparatory drawing, but a copy after the fresco, and is perhaps by Mantegna's great brother-in-law, Giovanni Bellini.

The next fresco to be painted must have been the *Assumption of the Virgin* in the apse (Plates I and II), originally allocated to Pizzolo. Here Mantegna displayed a similar ingenuity, which earned him the censure of two older artists, Francesco Squarcione and Giovanni Storlato, and the naive disapproval of the donor's widow, Imperatrice Ovetari. This fresco cannot therefore be dated after the scene of the *Archers Shooting at St. Christopher*, as has been suggested recently.

We owe the survival of the *Assumption* to the fact that in the nineteenth century it was detached from the wall and removed because it had begun to be affected by humidity. Although the area representing heaven has mistakenly been extended downwards, we still have the complete picture, though not in its original form. This neutral zone was added in order to lower the group of Apostles, so that they would

not appear above the sculptured altarpiece, which was at that time in the apse. The beholder would then see only the triumphant Madonna (not unlike Mantegna's *St. Eufemia* in Naples), tall and majestic, raising her arms like an early Christian *Virgo orans*, amid a host of exultant angels under the stars of the arch. It is easy to imagine the top and bottom zones joined together and thus to visualize the original appearance of the fresco. That is how it appears in an engraving made by Francesco Novelli before it had been tampered with. Here we have the compositional idea that was to culminate in Titian's sublime altarpiece in the Frari church in Venice.

What gave rise to the complaints about Mantegna's great fresco was the low view-point. Forced to adjust the given theme to a narrow strip of wall, the painter made ingenious use of the arch and adopted the expedient of treating the top of the monumental structure as the summit of the ascension and placing only four Apostles in the foreground below. They hold on to the pilasters in order to steady themselves. Four others appear behind them, considerably lower down, and the last four are not seen but are to be imagined still further down within the archway. It was such perspective devices that provoked foolish objections and ill-founded hostility. But that did not deter Mantegna from pursuing the same course when, having taken the place of his dead colleague, he came to paint the *Martyrdom of St. James* (Plates XII-XVI). With nearly all the figures placed prominently in the foreground, and the lovingly depicted shoulder of a hill girt halfway up with a wall and crowned by a castle, this is slightly reminiscent of Bono da Ferrara's no less spacious fresco of *St. Christopher Carrying the Christ Child across the Ford* (Fig. 6). The invention is here even more ingenious than in the previous scene, yet the means employed are subtler. In the foreground a soldier leans over a rustic fence made up of branches, with the railing held in a ring just inside the border of the picture. In the centre the Saint lies stretched out along the ground, his fine bearded head bound fast, while the executioner, dressed in rags and brutal of mien, is about to deliver the fatal blow with a hammer. This figure is reminiscent of Rogier van der Weyden, and admiration for the art of the Flemish master must also have inspired Mantegna to enliven the vast hillside with a multitude of minute beings, without disturbing the spontaneous rhythm of the two horsemen, one seen from behind, the other almost frontally, who flank the scene. This rhythm, underlined by the shield-bearer and the trio of young soldiers behind him, centres on the head of the Apostle, whose solemn, imperturbable calm is worthy of an ancient philosopher — a motif that Mantegna took over from a similar scene in the frescoes of Avanzo and Altichiero in the Lupa Chapel next to the Santo.

Art and virtuosity here speak with a single voice. Nothing survives of the influence of Pizzolo, not even the hanging garlands, nimble putti and coats of arms that Mantegna had painted in the two upper registers to correspond with the frescoes on the opposite wall.

As the entrance wall was to be left undecorated nothing now remained to be painted in the chapel except the two last scenes from the legend of St. Christopher (Plates XVII-XXV). And since we know that these had not been begun by 1457, when the legend of St. James was completed, we must conclude that Mantegna painted them, in spite of the criticism levelled at his earlier work, between receiving the call to Mantua and his arrival there at the end of 1459 or the beginning of 1460.

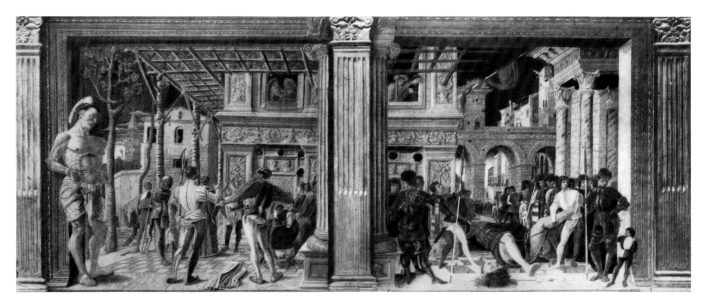

Fig. 13. Copy after Mantegna: *Archers Shooting at St. Christopher; St. Christopher's Body Being Dragged away after his Beheading.* (Cf. Plate XVII.) Paris, Musée Jacquemart-André.

Dispensing with all trivial decorative devices and availing himself of all the resources of perspective, he enclosed the two scenes in a frame as if they were seen through two wide windows. In fact, he went further and combined them into one, like two openings in an imposing portico divided in the middle by an Ionic column and supported on each side by pilasters, whose moulding is continued across the architrave. Thus the two scenes are the halves of a single setting, a single view of a kind of acropolis, which is reached from a street lined with brick-faced houses; in the distance at the left are a high wall and a bell-tower rising next to a church. The acropolis has a variegated pavement and the street leads into a central square dominated by a sumptuous marble palace. Its walls are decorated with the sculptured friezes and ancient reliefs so dear to Jacopo Bellini. Two wide windows are filled with spectators, and a trellis of green vines runs round the palace. Nearby are to be seen a fine colonnade, splendid arcades, and a flight of steps leading to a kind of Capitol.

In the foreground two moments are shown from the Canaanite giant's martyrdom: at the left the arrows loosed by the archers fall to the ground without touching him and one pierces the eye of the tyrant who looks on from the window of his palace; at the right the martyr's huge body is being dragged away by soldiers and the populace. Only the women do not lend a hand — they stare at the frightful spectacle from distant windows and terraces.

Critics who have misinterpreted the dignity with which Mantegna invested his figures right from the start have accused him of depicting marble statues rather than living beings. This fresco no longer affords grounds for such a charge, for the painter had now simplified his technique and has abandoned every device that might be traced back to a taste for the Gothic. The scene he has pictured here is agitated and full of movement, with some archers seated on the ground and preparing their bows, while others, having just discharged their bows, are surprised to find that their attempts have been in vain. One of them, his arms still stretched out, sees with amazement that his arrow falls to the ground ineffectually, another has already lowered his arm and is astonished to find that his arrow, diverted from its path, has lodged in the tyrant's eye. Halberdiers and

[37]

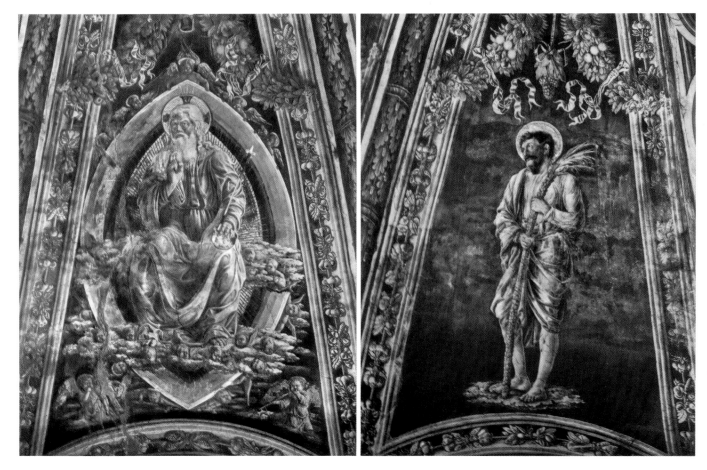

Fig. 14. Niccolò Pizzolo: *God the Father;* Mantegna: *St. Christopher.* Spandrels on the ceiling of the apse (Fig. 8, compartments G 3 and G 4).

onlookers ask themselves why the laws of nature have been subverted. After remaining untouched by the arrows, St. Christopher was beheaded. On the right, two heavily armed soldiers make way for the group that laboriously drags the corpse along; the head lay in the foreground in a pool of blood, but this part of the fresco has badly suffered and only a few traces remain. In the middle of the nineteenth century the fresco, already corroded by saltpetre, especially along the bottom, was detached from the wall and brought to safety; hence it has survived, though in a damaged condition. But old copies, such as the mediocre but faithful one in the Musée Jacquemart-André in Paris (Fig. 13), enable us to read the whole of this marvellous composition, which is so rich in detail, yet so clear and unified in what remains of the original, a rare treasure.

The truly miraculous impression we receive from this picture is produced not merely by the master's admirable technique, but above all by the life he infused into the picture, giving each brushstroke and each tint an expressive value. Nothing here is transient, weak, redundant: an air of infinity pervades and ennobles this scene, and from it Antonello da Messina, once he had left behind the harsh world of glass and stone and the sublime detachment of Piero della Francesca, and had reached the greener shores of true painting, was able to take the magical background of his *St. Sebastian.*

Perspective had now become Mantegna's inspiration: instead of suggesting to him novel solutions rich in surprises, it gave the figures and objects in his work a rhythm which is both music and perfect balance. Perspective was the smooth road by which he

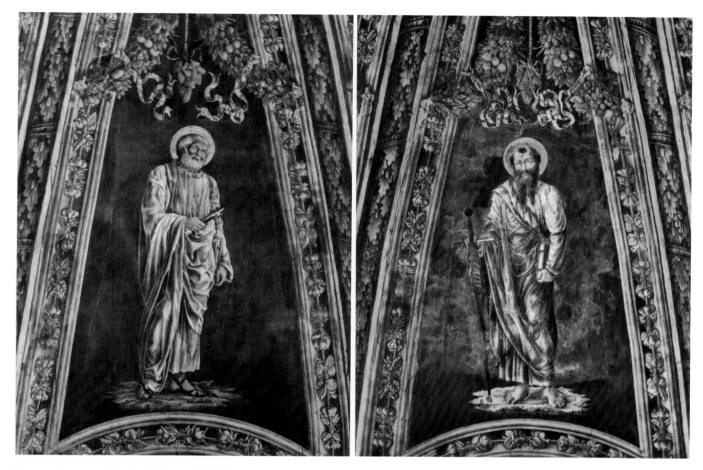

Fig. 15. Mantegna: *The Apostles Peter and Paul*. Spandrels on the ceiling of the apse (Fig. 8, compartments G2 and G5).

reached in the Camera degli Sposi, twenty years later, the perfect symphonic unity between the walls and the ceiling. Variety is thus absorbed in unity, not just without breaking it up, but even giving it greater clarity.

When we ponder all this, is it still of any interest to record that Mantegna — as we are told by Vasari, who saw only the surface of things rather than their immortal spirit — portrayed in this fresco scholars, notables and artists of his time? That his own slim head can be seen next to the fleshy face of Pizzolo under the helmet? And that among the solemn spectators on the right we can recognize Onofrio di Palla Strozzi (the same who had his father's tomb in Florence built by Pietro Lamberti, the pioneer of the "new" sculpture in Venice), the physician Girolamo Valle and the jurist Bonifacio Frigimelica? And among those who drag the corpse, the Hungarian bishop Janus Pannonius, Messer Bonzamino, and finally the goldsmith of Pope Innocent VIII, Niccolò Baldassarre da Leccio? These are but trivial curiosities.

Besides, my suspicion that the gigantic frescoed head on the right side of the arch between chapel and apse represents Pizzolo, far from round-faced, casts a shadow of doubt upon those identifications — all the more as the scowling face on the left side of that arch (Fig. 9) is undoubtedly a portrait of Mantegna himself, with that large, resolute face, disdainful mouth and big nose, which the master immortalized many years later in the bronze head cast for his funerary chapel in Mantua — a portrait that seems to follow us with its austere gaze and to grieve with us over the unhappy fate that has befallen so much of his work and his poetry.

[39]

CONCLUSION

It was in Padua that the Tuscan Renaissance — the poetic expression of the Christian world, which had emerged from the turmoil of the Middle Ages and the conflict and reconciliation between barbarism and tradition — reached the end of its early period and began to conquer Italy, and so Europe. Here, if anywhere, Renaissance and humanism had to come together. For, whatever may be said, this could not have happened in the work of Brunelleschi, of Masaccio, of Paolo Uccello, of Andrea del Castagno, of Domenico Veneziano, of Donatello. It was only in the second generation of Florentine artists that an interest in antiquity made itself felt — and even this interest was still romantic in character.

In Padua this romanticism was older and had long been in the making. It went back to the time of Petrarch's visits and to the medals of the Carrara family; it passed through Albertino Mussato and patriotic historians who ascribed the foundation of their city to the mythical Antenor of Troy and even built a tomb for him; and so it reached Mantegna himself. There is no doubt that the young artist was a most devoted admirer of that classical past and that no one was more responsive to it. In his youth he found that this enthusiasm was shared by his father-in-law, Jacopo Bellini, and he translated the antique into a pictorial world worthy of its source. No one knew better how to make antiquity his own, and whenever it suited his purpose, he brought it to life in a way that not only arouses the archaeologist's admiration, but also recaptures its authentic gestures and, one might say, its essential spirit, because that was also the spirit of his own art. The antique is here evoked in forms that have its true flavour, its dignity, its bearing, like the words of Shakespeare when he re-creates Julius Caesar.

Mantegna became the unrivalled interpreter of the antique because the aspects of antiquity he chose to depict were those that expressed what is timeless and those that satisfied his striving for all that was sublime, serene and dispassionate, even if he did not share the divine detachment of a Piero della Francesca. In his lofty world all suffering is checked and concealed — it does not lend itself to overt gestures, to emphases that escape from Olympian self-control and impair perfect composure. The disharmony between the antique and the Renaissance came with the next generation: scattering classical elements everywhere at random, they invested it, like Parenzano in the cloister of S. Giustina, with a moral authority to be placed beside the Old and New Testaments, or used it inappropriately as embellishment of sacred objects, like Riccio on his paschal candlestick in the Santo. Mantegna's classicism is his very style, a style that his contemporaries, who likened his figures to ancient statues, censured as commonplace. But those of us endowed with a perceptive sensibility can detect, under the surface, the beating of a greater heart than in some of the agitated frescoes of Tiepolo.

What we detect is the throbbing of that Italian civilization which was then unfolding as a pattern for the world and which rid itself for ever of the burden of physical substance — that monstrous weight that was the incubus of the Romanesque world

and which the Gothic gave only the illusion of having overcome, trying to escape from it by way of a dream. In one of those rare moments in history, which we owe only to Athens and to Florence, the human spirit attained mastery over matter without losing the dream — an achievement proclaimed first by Tuscany and shortly afterwards by Padua, in the language of Mantegna, making man aware of himself as he confronted the universe now that he had fully discovered it: the earth, the heavens and himself. But puny man no longer measures himself against the universe like Faust, the son of the misty north; he feels himself to be part of it and penetrates it with a vital and reverent spirit. Did Mantegna, then, only repeat the great Florentine achievement? He was its consummation, certainly, but he was also something new, like a light lit from another light.

The special character of Venetian art was due to the heritage it had received through Ravenna and, less strongly, through Byzantium — a heritage that gave it some flavour of Late Roman art and of the art of the exarchate. It was this climate that helped Mantegna to find himself and to make him, as befits a genius, the authentic interpreter of a long-lost reality.

The imitation of statues, the solemnity of his figures, the style reminiscent of carved gems, everything that earned him the strongest censure, was the very essence of his art, which was to that extent typically Venetian. That hieratic majesty, which the somnolent Madonnas of Antonio Vivarini already shared with magic "basilissae", in Mantegna's work became a means to an end and hence part of his style. Later it was also adopted as a stylistic method by painters who transcended the bounds that limited Mantegna's art: Gentile and Giovanni Bellini, Giorgione and Titian. It was not until the middle of the sixteenth century that this current was diverted by mannerist influences from Tuscany and central Italy, and also by the pre-Baroque art of Correggio.

This current began to flow first in Venetian art, and it was precisely in the work of Mantegna that it took shape in a unique and fully-developed way — a clear sign that it formed part of the historic civilization that radiated so brightly from under the banner of St. Mark's. The prominence of antique elements was not a drawback of this style, but its very substance — the framework of art in the exuberant world of the Serenissima. And as she had, in the early fifteenth century, both the lagoon and the coastal regions under her sway, it is pleasant to remember that her standard-bearer came from the terra firma — almost as a sign of his perfect allegiance to her.

But Mantegna did not share what was at the core of Venetian art — the devotion, first to colour and then to what is painterly. In this respect he was more Tuscan than the Tuscans, subordinating colour to form and giving it an ever smaller part to play in his work, until that precious element was often reduced to an exquisite chiaroscuro.

His logical spirit was quick to see the fullest implications of the discoveries of the Renaissance, and so he soon dispensed with decorative flourishes, a heritage of the Gothic tradition, which was still in fashion all around him. But he also knew how to exploit the laws of perspective — as the true poet, according to Baudelaire, avails himself of good rhetoric — to obtain ever more ample and consistent rhythms, first rhyming one picture with another, and later on complete groups of paintings, such as those in the Camera degli Sposi in Mantua and that ghost of a masterpiece, the *Triumph of Caesar* at Hampton Court.

The master pursued this road to the end with untiring steps. He had the robust constitution of a peasant, as we can see from his marvellous self-portraits, the earliest of which is precisely here, in the Ovetari Chapel (Fig. 9). He was not a man of servile temperament — throughout his life he had the dignity of the true artist, coupled with perfect honesty, and thus he earned the highest respect of the Gonzaga court and was treated like a prince of equal standing by his employers, who were ready to defend him even in the eccentricities of his old age.

To say that with the loss of the Ovetari Chapel we have lost all of him is fortunately not true. But what we have lost is the key to his art, a magnificent prelude, the enchanted cradle of his painting. Every time I walked into that doomed church my mind rejoiced in that dream which art, when it is truly art, conjures up for us, and when I came out I felt, even amid the troubles of life, that I was consoled, that I had new faith, that I could breathe more freely. I remember how, on one of my last visits, I remained almost ecstatic for hours and hours, while nearby stood someone else also rapt in mute contemplation. When we roused ourselves and went out we recognized one another: it was Roger Fry, the English painter and critic, who was to die shortly afterwards. Neither of us could then have believed — for art seems to have some claim on immortality — that one sad day that world would crumble into dust, leaving behind, apart from the two detached frescoes and the sculptured altarpiece, no more than a few poor fragments, and also something less enduring: a vivid and reverent memory, which I have supplemented in these pages with what is to be learnt from old documents and all other available sources.

SELECT BIBLIOGRAPHY

VASARI, G., *Le Vite*, Florence, 1550, enlarged edition, 1568 (ed. G. Milanesi, 1885).

SCARDEONE, B., *De antiquitate Urbis Patavii*, Basle, 1560.

CROWE, J. A., and CAVALCASELLE, G. B., *A History of Painting in North Italy*, London, 1871.

KRISTELLER, P., *Andrea Mantegna*. London and New York, 1901.

BERENSON, B., *North Italian Painters of the Renaissance*, London and New York, 1907.

LAZZARINI, V., *Documenti relativi alla pittura Padovana del secolo XV*, Venice, 1908.

TESTI, L., *La Storia della Pittura Veneziana*, Bergamo, 1909.

KRISTELLER, P., 'Francesco Squarcione e le sue relazioni con Andrea Mantegna', in *Rassegna d'Arte*, 1909.

VENTURI, A., *Storia dell'Arte Italiana*, vol. VII, part III, Milan, 1914.

FIOCCO, G., *L'Arte di Andrea Mantegna*, Bologna, 1926.

LONGHI, R., 'Lettera pittorica a Giuseppe Fiocco', in *Vita Artistica*, 1926, p. 127.

RIGONI, E., 'Nuovi documenti sul Mantegna', in *Atti dell'Istituto Veneto di SS.LL.AA.*, 1927-8, part II, p. 1165.

FIOCCO, G., in Thieme-Becker, *Allgemeines Lexikon . . .*, vol. XXIV (s.v. Mantegna), Leipzig, 1930.

MOSCHETTI, A., 'Per l'integrità della Cappella Ovetari e di un affresco del Mantegna', in *Bollettino del Museo Civico di Padova*, 1932, p. 1.

FIOCCO, G., 'Andrea Mantegna o Giambellino?', in *L'Arte*, 1933, p. 185.

FOGOLARI, L., 'Lavori nella Cappella Ovetari', in *Bollettino d'Arte*, 1933.

MOSCHETTI, A., in Thieme-Becker, *Allgemeines Lexikon . . .*, vol. XXVII (s.v. Pizzolo), Leipzig, 1933.

FIOCCO, G., *Mantegna*, Milan, 1937.

RAGGHIANTI, C. L., 'Casa Vitaliani', in *La Critica d'Arte*, 1937, p. 243.

MOSCHINI, V., *Gli affreschi di Mantegna agli Eremitani di Padova*, Bergamo, 1944.

TIETZE, H. and E., *The Drawings of the Venetian Painters*, New York, 1944.

FORLATI, F., and GENGARO, M. L., *La chiesa degli Eremitani a Padova*, Florence, 1945.

FIOCCO, G., *Mantegna: La Cappella Ovetari . . .*, Milan, n.d. (1947).

RIGONI, E., 'Il pittore Nicolò Pizolo', in *Arte Veneta*, 1948, p. 141.

VERTOVA, L., *Mantegna*, Florence, 1950.

COLETTI, L., *Pittura Veneta del Quattrocento*, Novara, 1953.

TIETZE, E., *Andrea Mantegna*, London 1955 (Italian ed., Florence, 1955).

BETTINI, S., 'Neoplatonismo fiorentino e averroismo veneto in relazione con l'arte', in *Atti e Memorie dell'Accademia Patavina di SS.LL.AA.*, 1955-6, vol. LXVIII, p. 2.

TAMASSIA, A. M., 'Visioni di antichità nell'opera del Mantegna', in *Rendiconti della Pontificia Accademia Romana di Archeologia*, 1955-6, p. 213.

CIPRIANI, R., *Tutta la pittura del Mantegna*, Milan, 1956.

PALLUCCHINI, R., *La pittura veneta del 400* (course of lectures given at the University of Padua), 1955-6, part I.

PACCAGNINI, G., *Mantegna, La Camera degli Sposi*, Milan, 1957.

COLETTI, L., *La Camera degli Sposi del Mantegna a Mantova*, Milan, 1959.

FIOCCO, G., *L'arte di Andrea Mantegna*, Venice, 1959.

MURARO, M., 'A Cycle of Frescoes by Squarcione in Padua', in *The Burlington Magazine*, 1959, p. 89.

BONICATTI, M., 'Nota Mantegnesca', in *Commentari*, 1961, p. 247.

FIOCCO, G., *Le pitture del Mantegna*, Turin, 1961.

PACCAGNINI, G., *Andrea Mantegna, Catalogo della Mostra*, Venice and Milan, 1961.

CASTELFRANCO, G., 'Note su Andrea Mantegna', in *Bollettino d'Arte*, 1962, p. 23.

LONGHI, R., 'Crivelli e Mantegna: due mostre interferenti e la cultura artistica del 1961', in *Paragone*, 1962, p. 13.

MELLINI, G. M., and QUINTAVALLE, A. C., 'In margine alla Mostra del Mantegna', in *Critica d'Arte*, 1962, p. 1.

RAGGHIANTI, C. L., 'Codicillo mantegnesco', in *Critica d'Arte*, 1962, p. 23.

BONICATTI, M., *Aspetti dell'Umanesimo nella pittura veneta dal 1455 al 1515*, Rome, 1964.

CAMESASCA, E., *Mantegna*, Milan, 1964.

PACCAGNINI, G., 'Cronologia della Cappella Ovetari', in *Arte, pensiero e cultura*, Florence, 1965, p. 77.

ROMANINI, A. M., 'L'itinerario pittorico del Mantegna e il "primo" Rinascimento padano veneto', in *Arte in Europa. Scritti di Storia dell'Arte in onore di Edoardo Arslan*, vol. I, Milan, 1966, p. 437.

ZAVA BOCCAZZI, F., *Mantegna*, Florence, 1966.

GARAVAGLIA, N., *L'opera completa del Mantegna*, Milan, 1967.

BETTINI, S., and PUPPI, L., *La chiesa degli Eremitani a Padova*, Vicenza, 1970.

RIGONI, E., *L'arte rinascimentale in Padova. Studi e Documenti*, Padua, 1970.

BATTISTI, E., 'Mantegna come prospettico', in *Arte Lombarda*, 1971, p. 98.

PUPPI, L., 'Nuovi documenti (e una postilla) per gli anni padovani del Mantegna', in *Antichità Viva*, 1975, no. 1, p. 3.

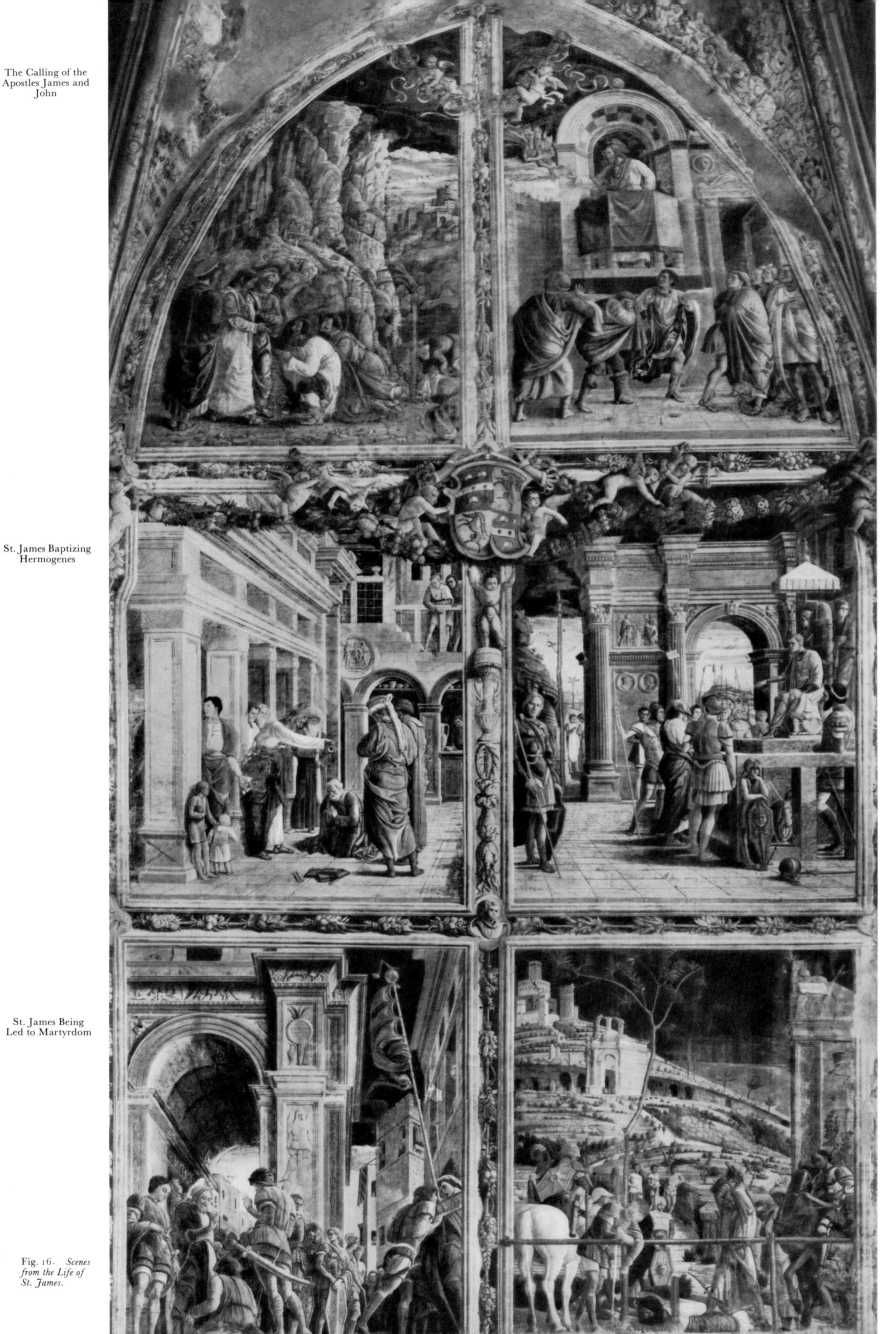

The Calling of the
Apostles James and
John

St. James Speaking
to the Demons Sent
against him by the
Magician
Hermogenes

St. James Baptizing
Hermogenes

St. James before
Herod Agrippa

St. James Being
Led to Martyrdom

The Martyrdom of
St. James

Fig. 16. *Scenes
from the Life of
St. James.*

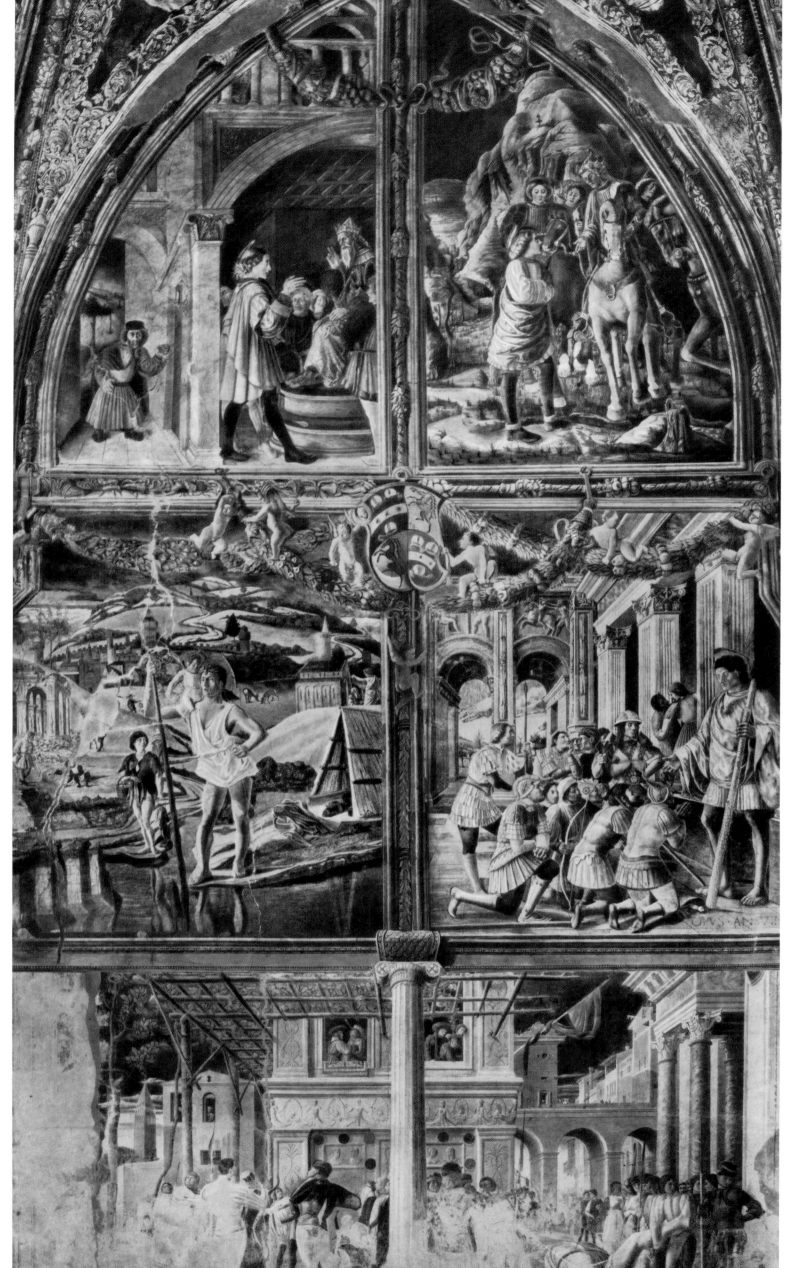

St. Christopher
before the King

St. Christopher
Refusing to Serve
the King of the
Demons

St. Christopher
Carrying the Christ
Child across the
Ford

St. Christopher
Preaching

Archers Shooting at
St. Christopher

St. Christopher's
Body Being
Dragged away after
his Beheading

Fig. 17. *Scenes
from the Life of
St. Christopher.*

THE ASSUMPTION OF THE VIRGIN

Plate I. Detail from *The Assumption of the Virgin.*

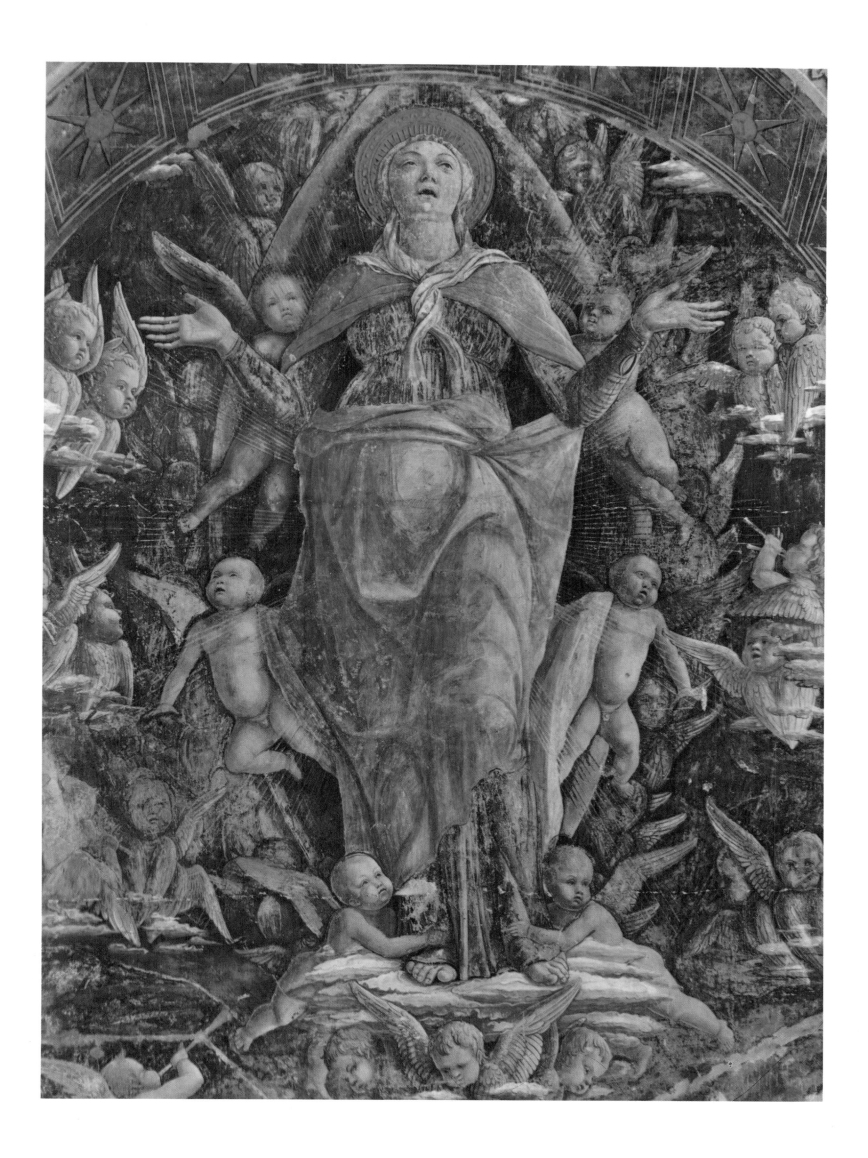

Plate II. Detail from *The Assumption of the Virgin* (original size).

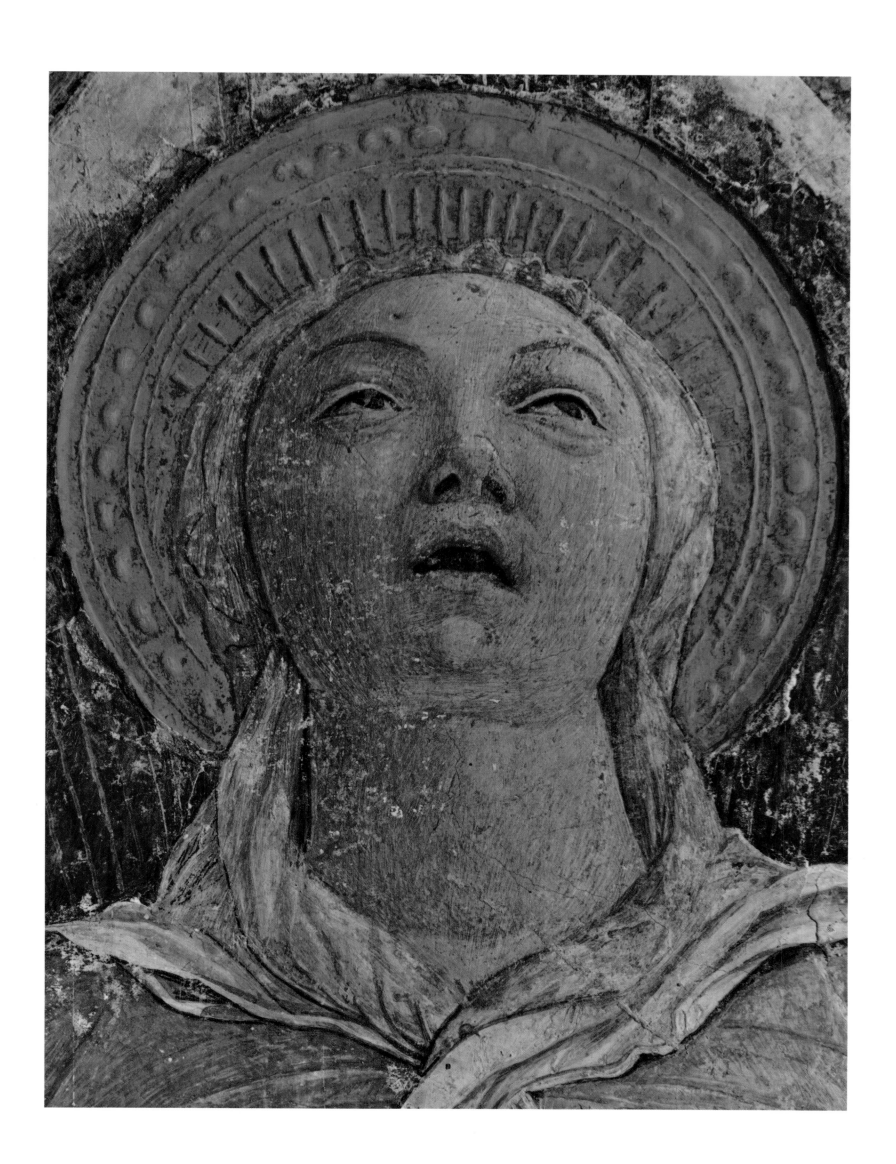

ST. JAMES BAPTIZING HERMOGENES
AFTER HIS CONVERSION

Plate III. *St. James Baptizing Hermogenes.*

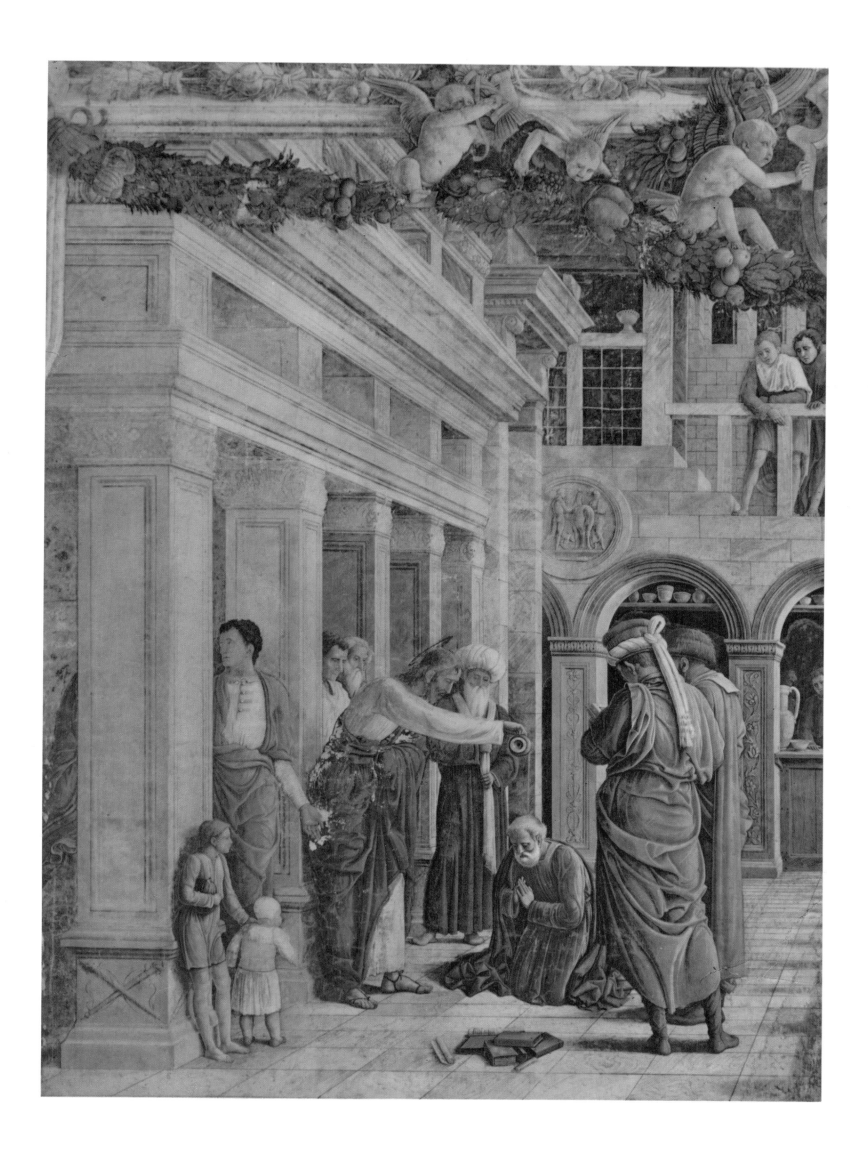

Plate IV. Detail from *St. James Baptizing Hermogenes* (Plate III).

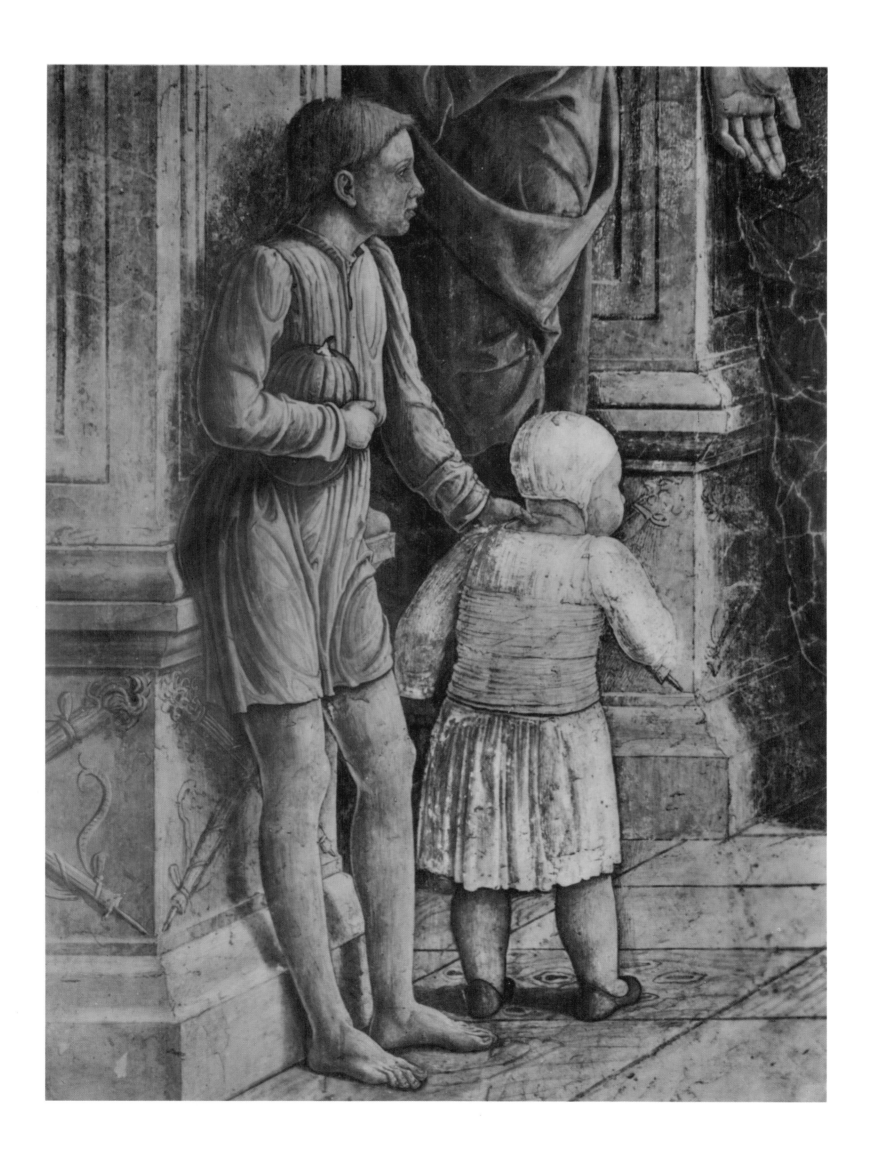

Plate V. Detail from *St. James Baptizing Hermogenes* (Plate III).

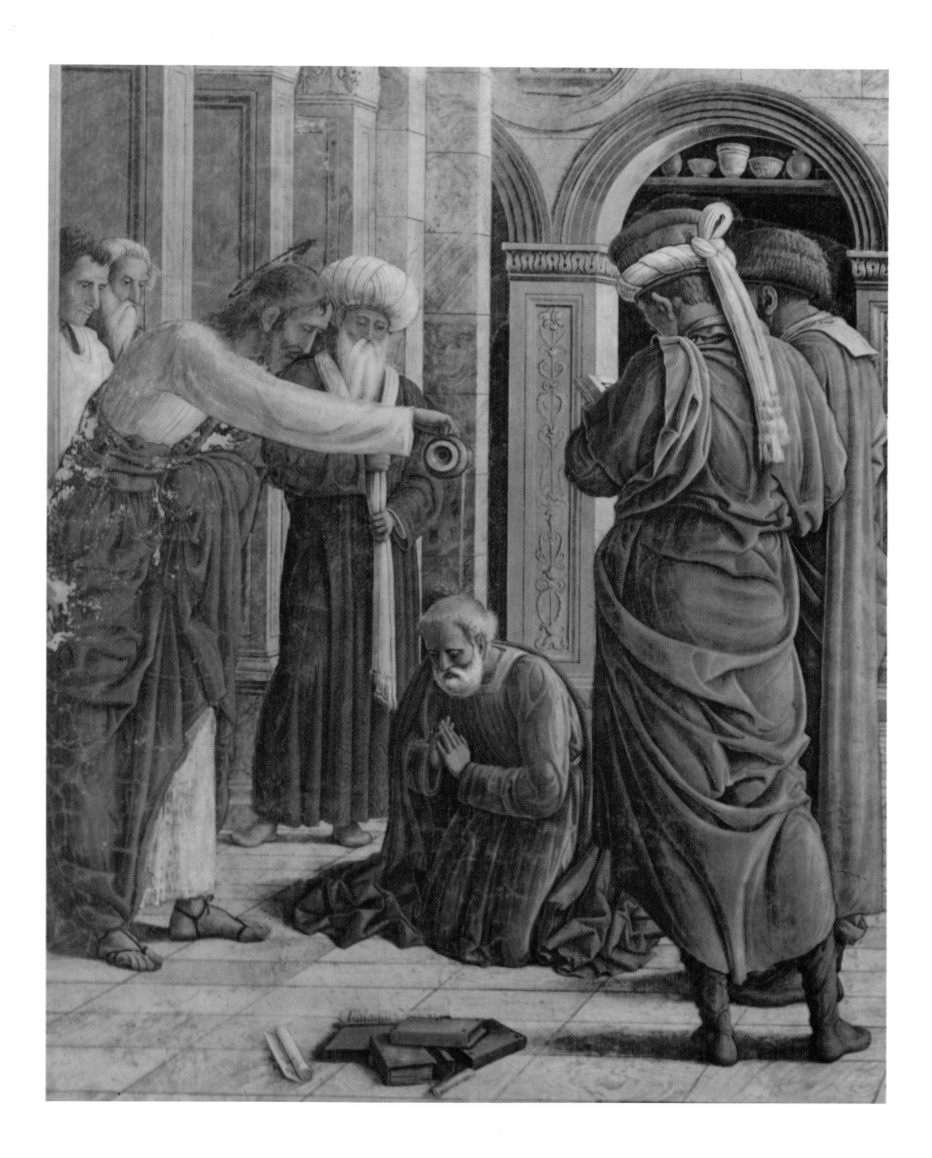

Plate VI. Detail from *St. James Baptizing Hermogenes* (Plate III).

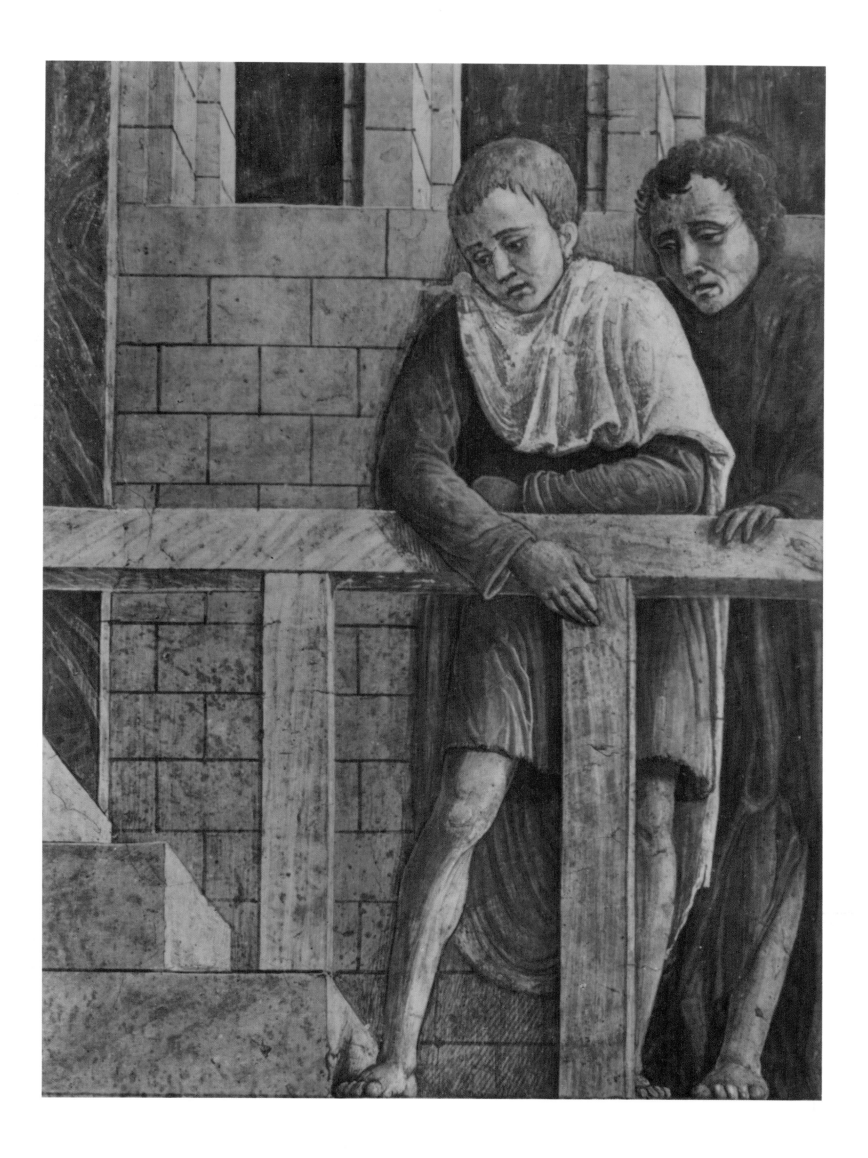

ST. JAMES BEFORE HEROD AGRIPPA

Plate VII. *St. James before Herod Agrippa.*

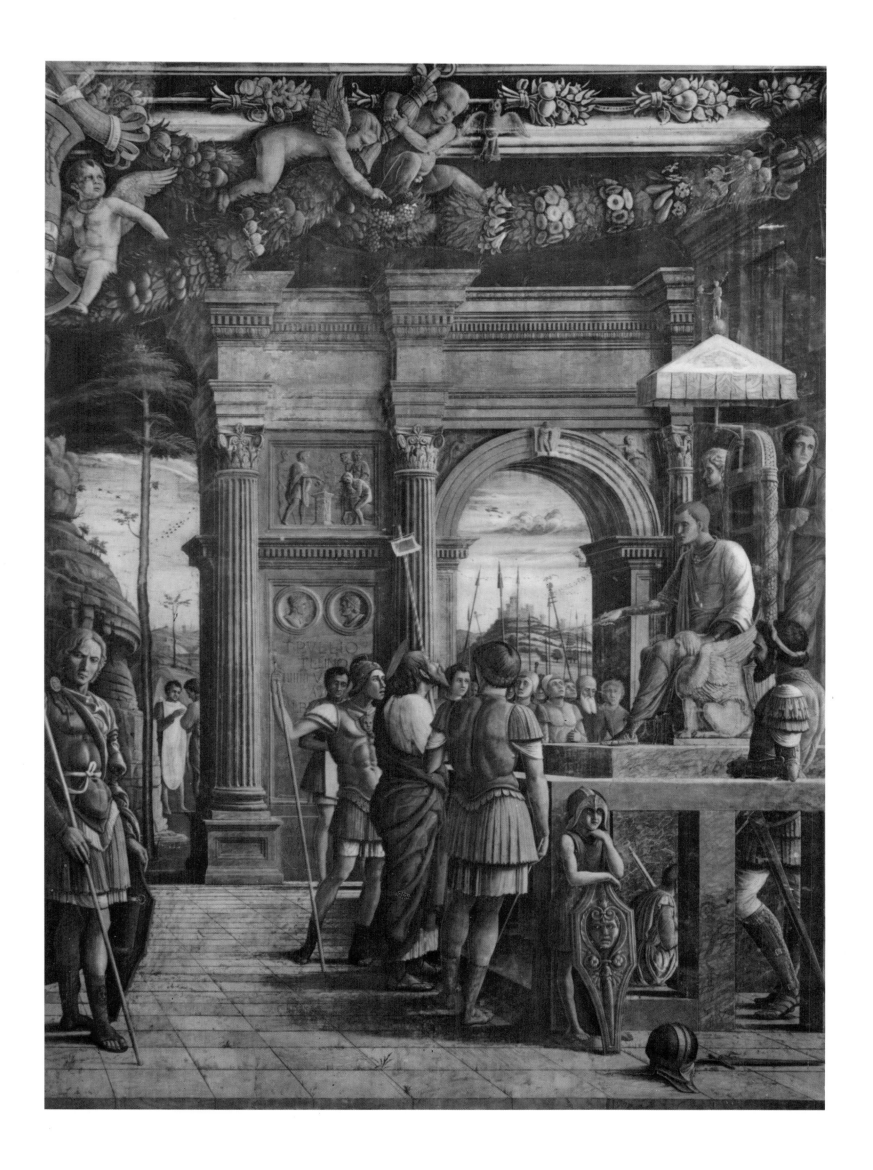

Plate VIII. Detail from *St. James before Herod Agrippa* (Plate VII).

Plate IX. Detail from *St. James before Herod Agrippa* (Plate VII).

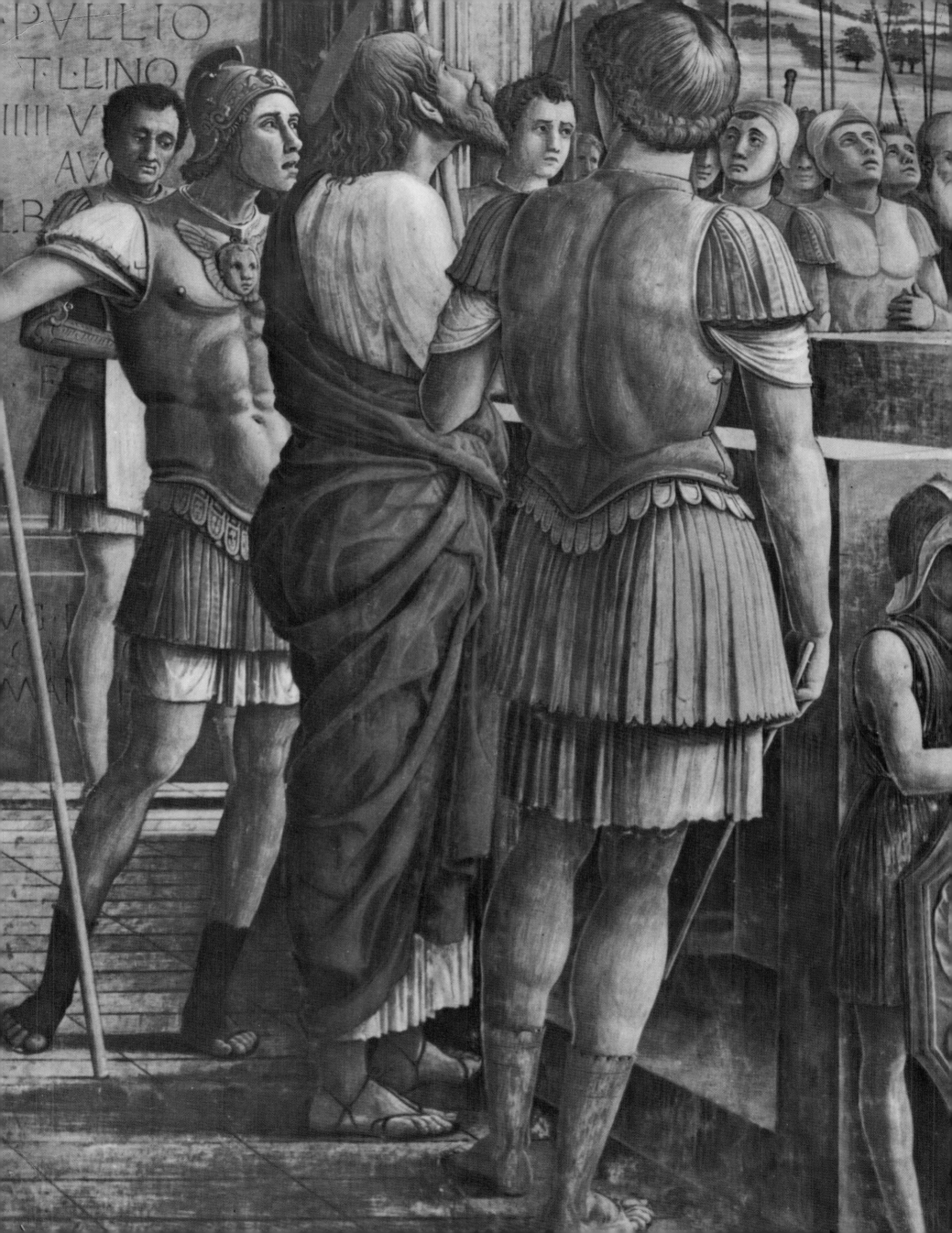

ST. JAMES BEING LED TO MARTYRDOM

Plate X. *St. James Being Led to Martyrdom.*

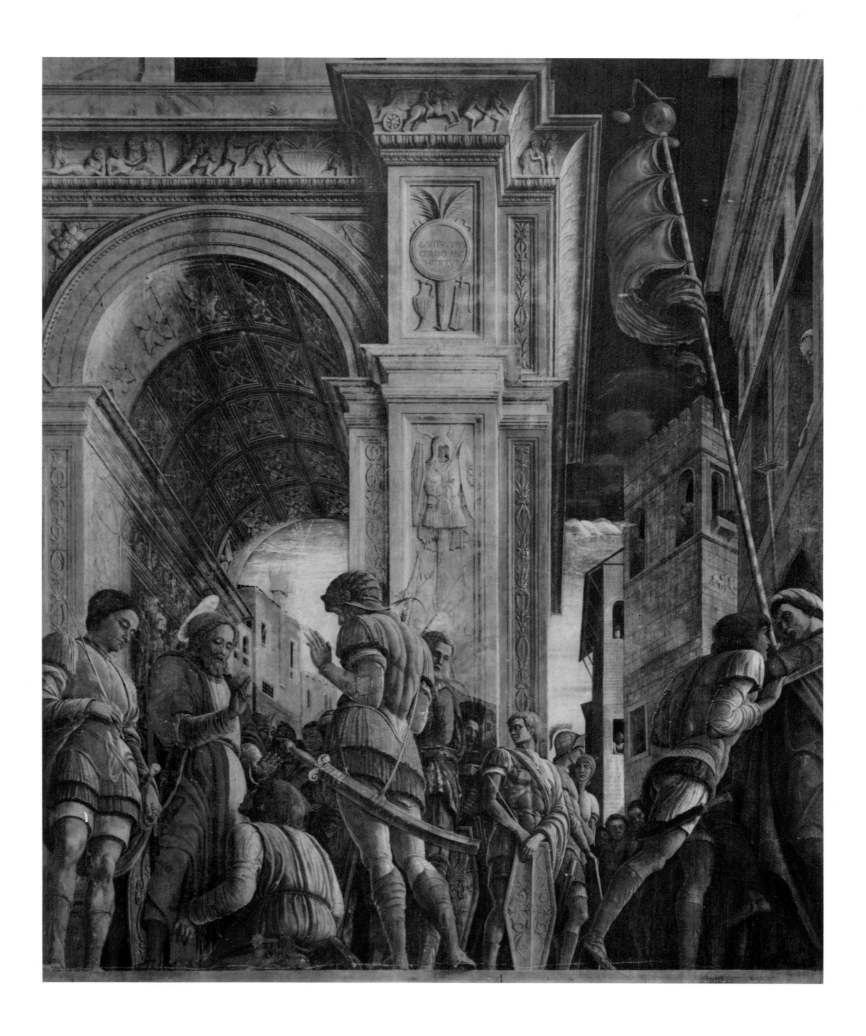

Plate XI. Detail from *St. James Being Led to Martyrdom* (Plate X).

THE MARTYRDOM OF ST. JAMES

Plate XII. *The Martyrdom of St. James.*

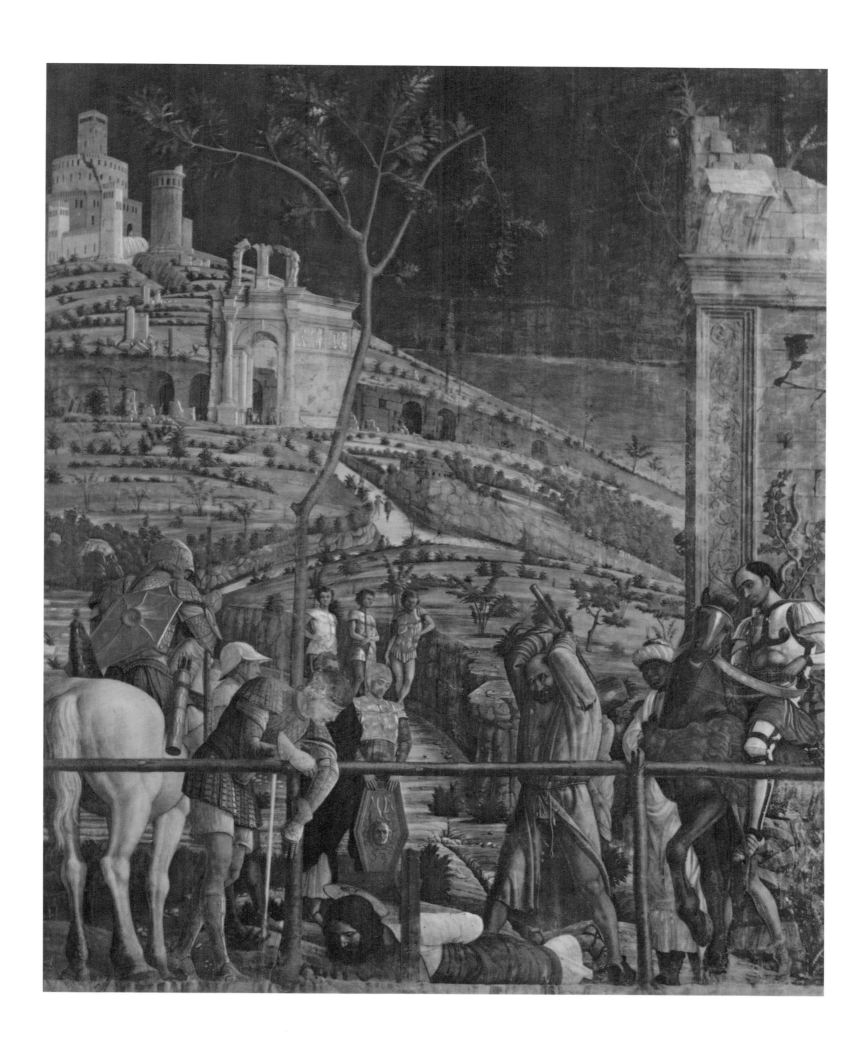

Plate XIII. Detail from *The Martyrdom of St. James* (Plate XII).

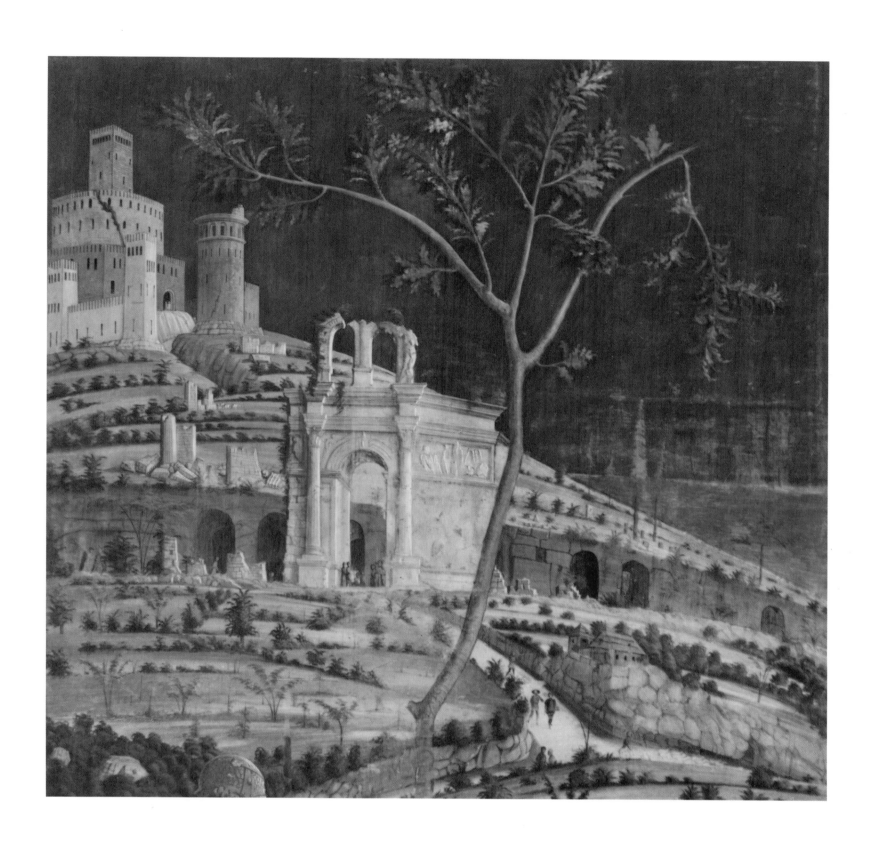

Plate XIV. Detail from *The Martyrdom of St. James* (Plate XII).

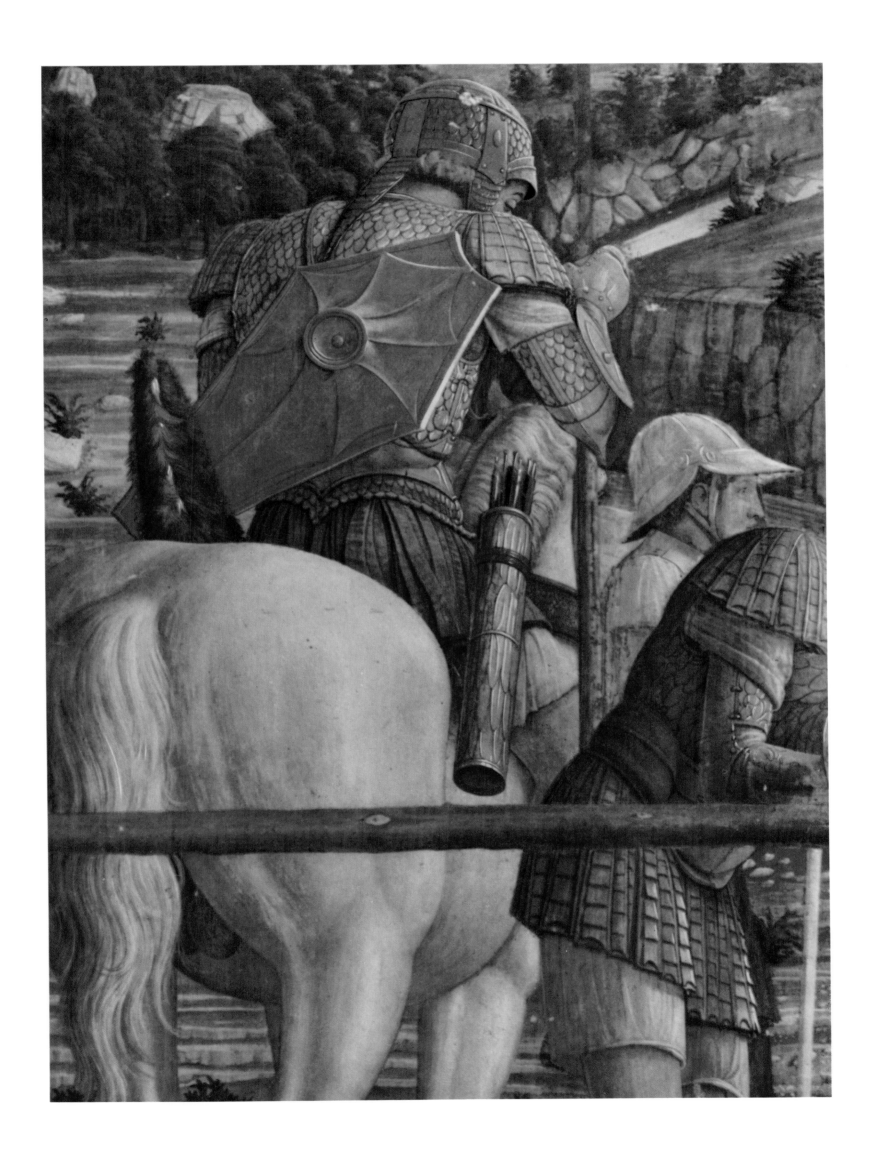

Plate XV. Detail from *The Martyrdom of St. James* (Plate XII).

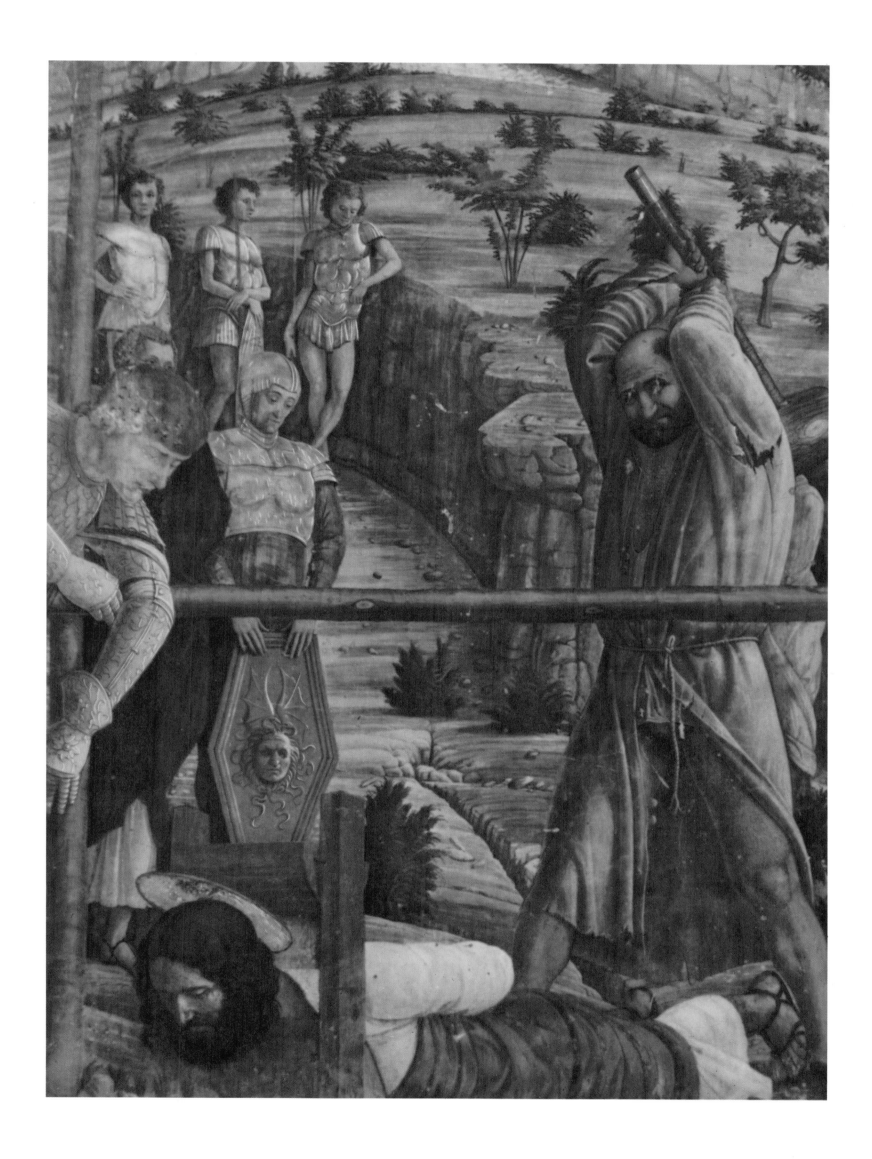

Plate XVI. Detail from *The Martyrdom of St. James* (Plate XII).

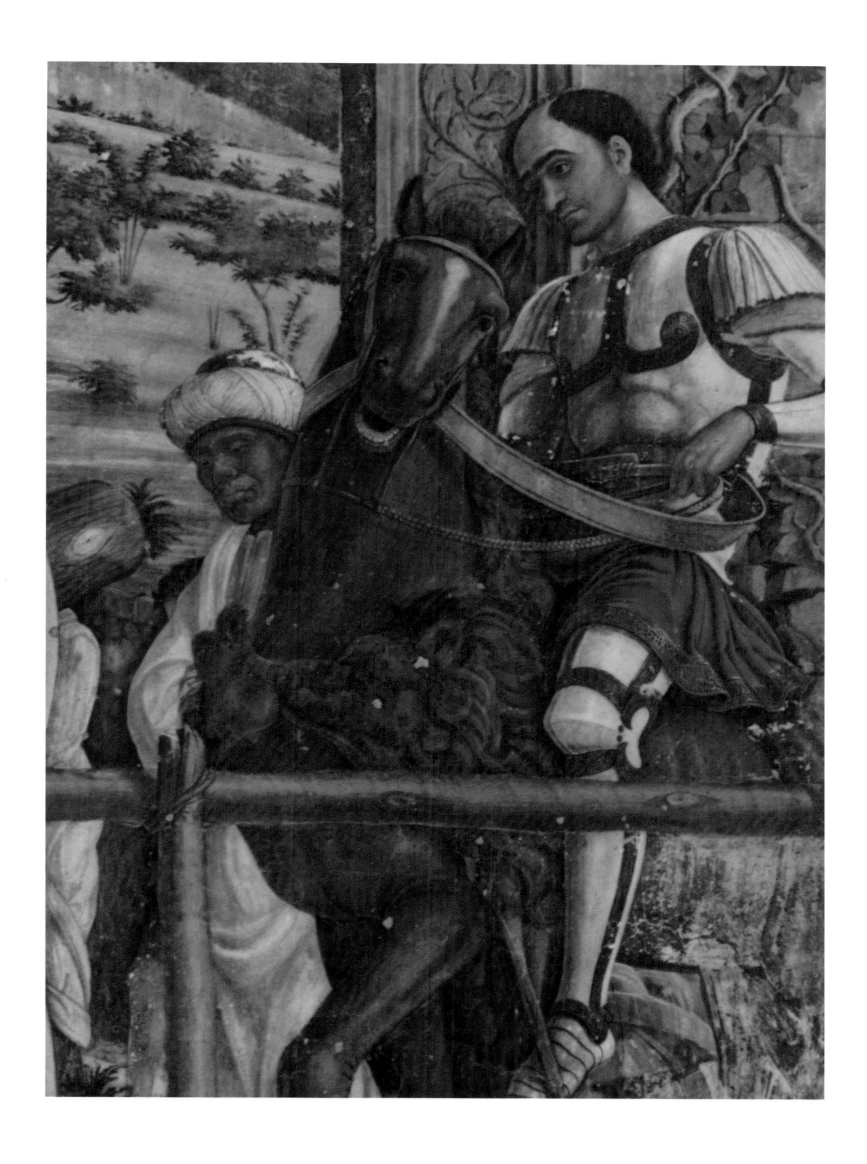

ARCHERS SHOOTING AT ST. CHRISTOPHER
and
ST. CHRISTOPHER'S BODY BEING DRAGGED AWAY
AFTER HIS BEHEADING

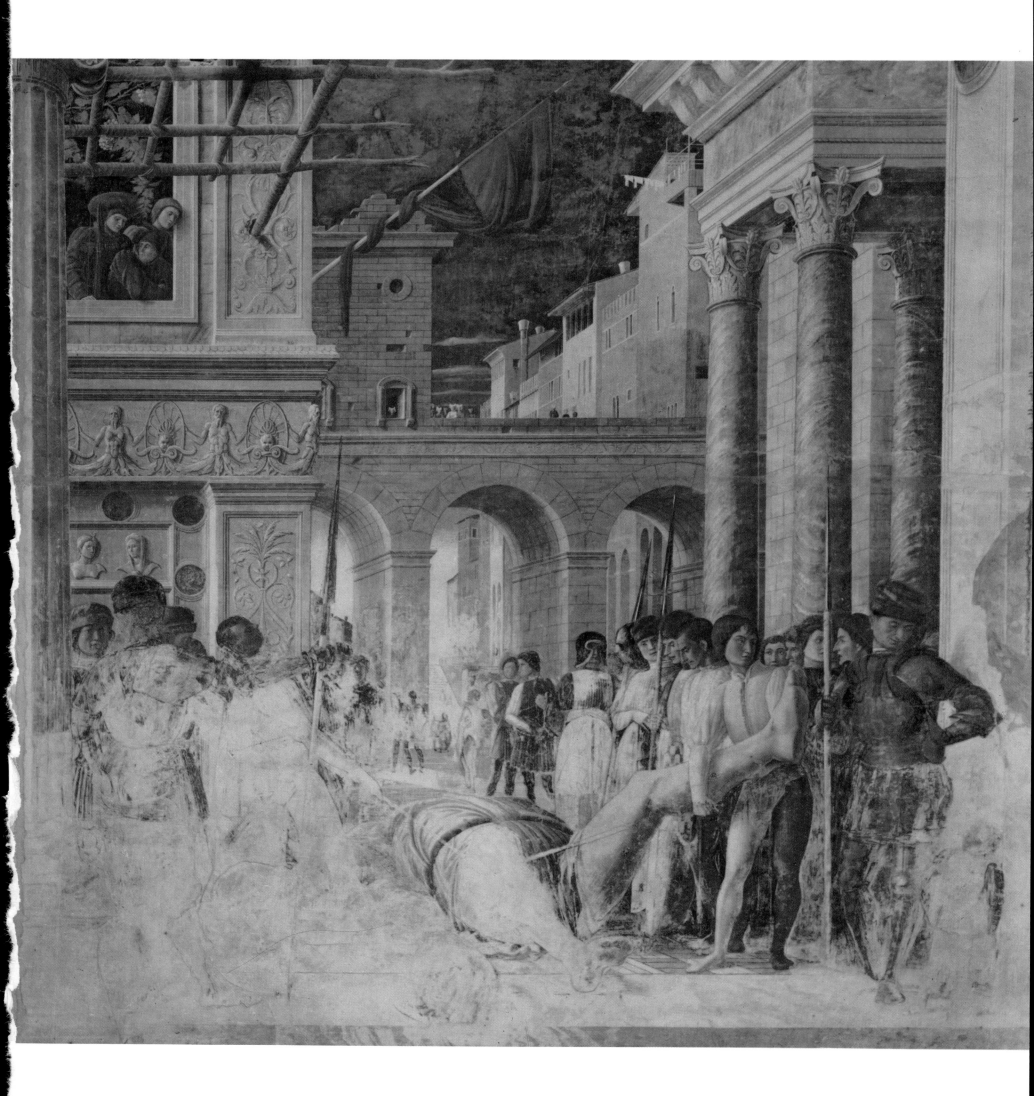

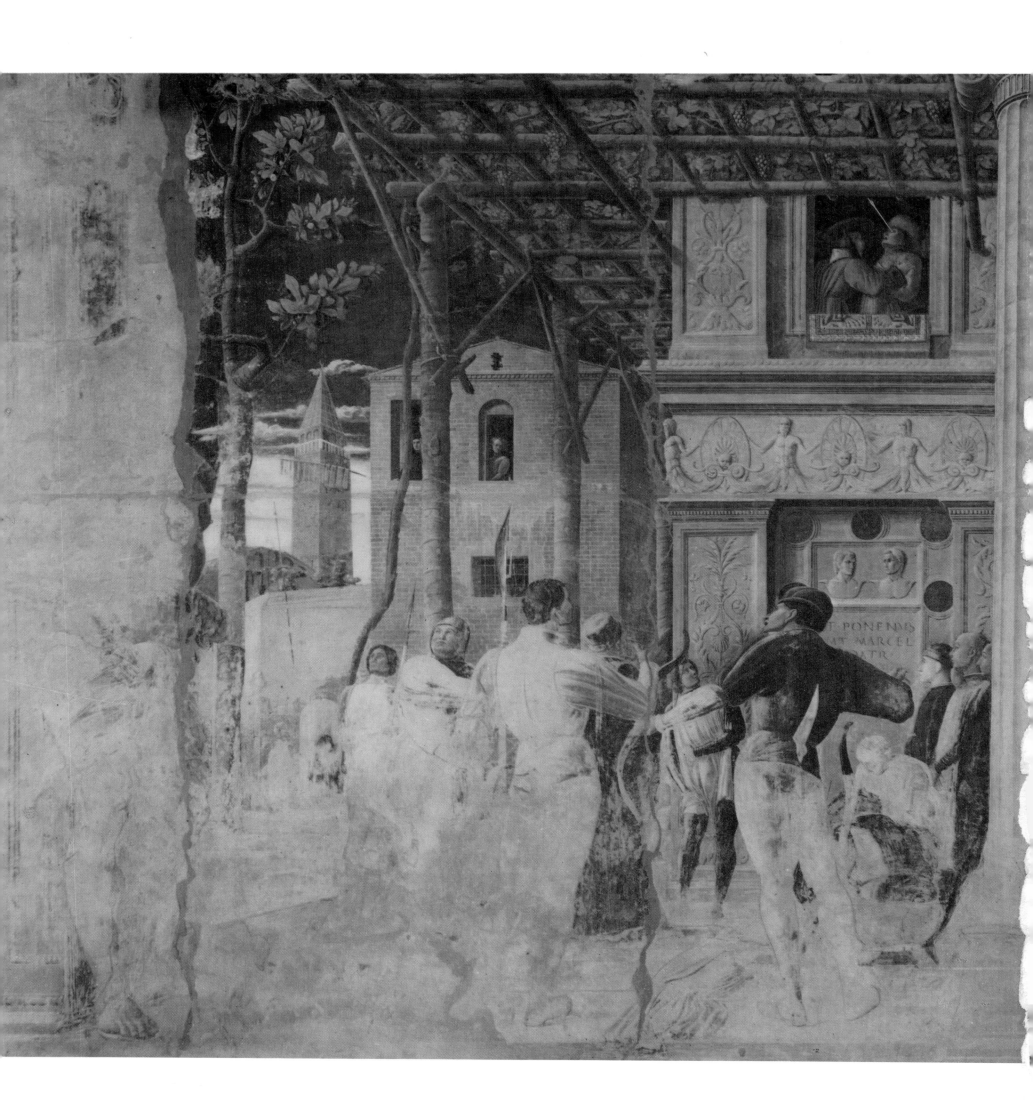

Plate XVIII. Detail from *Archers Shooting at St. Christopher* (Plate XVII).

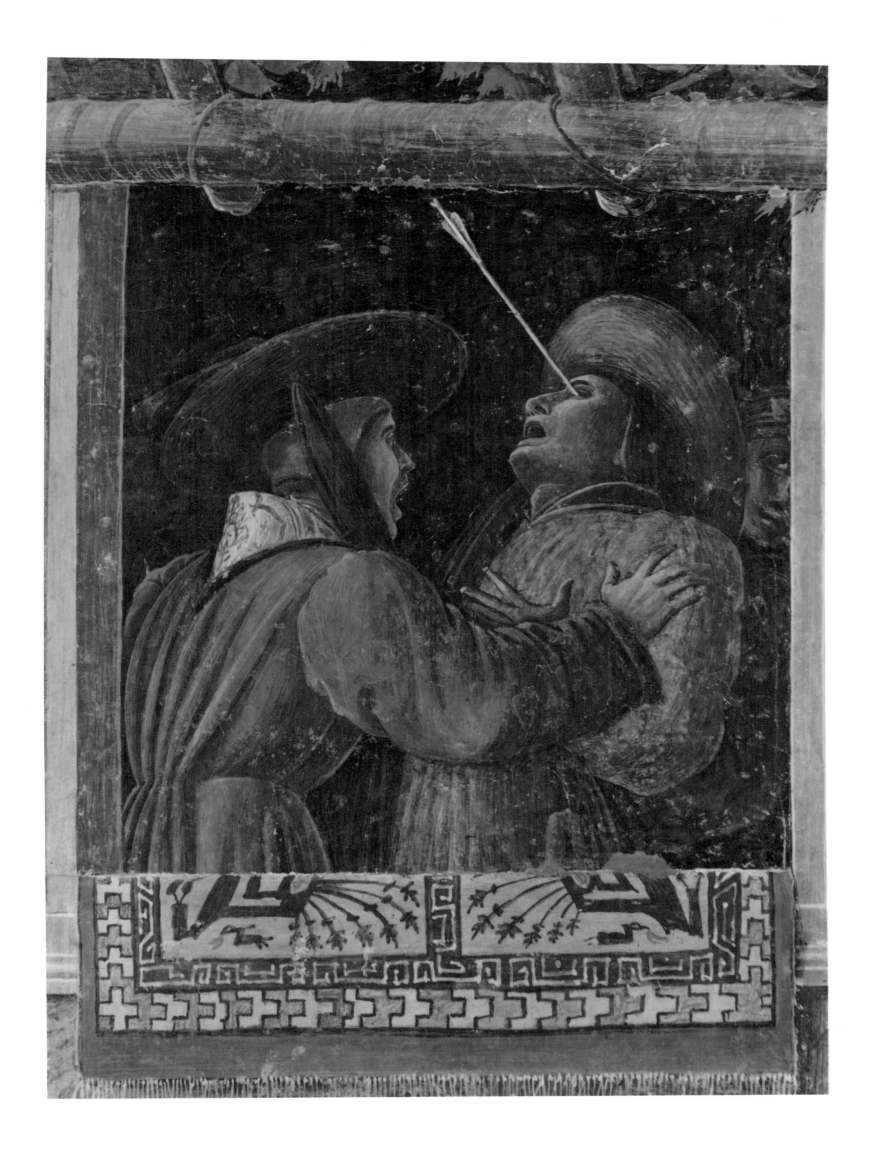

Plate XIX. Detail from *Archers Shooting at St. Christopher* (Plate XVII).

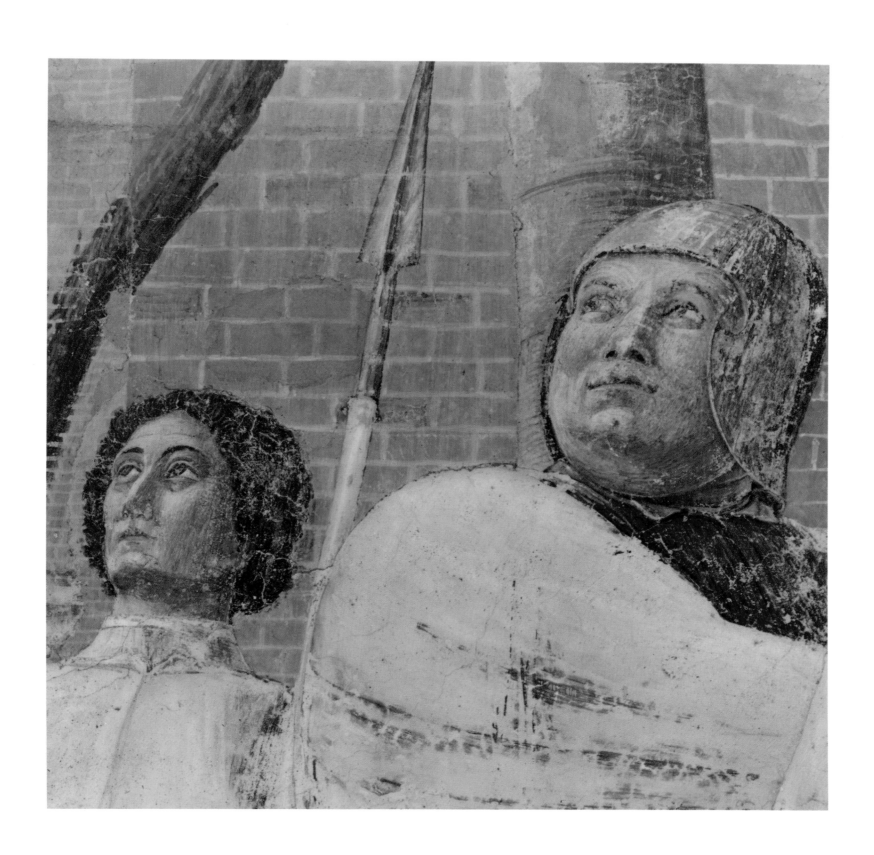

Plate XX. Detail from *Archers Shooting at St. Christopher* (Plate XVII).

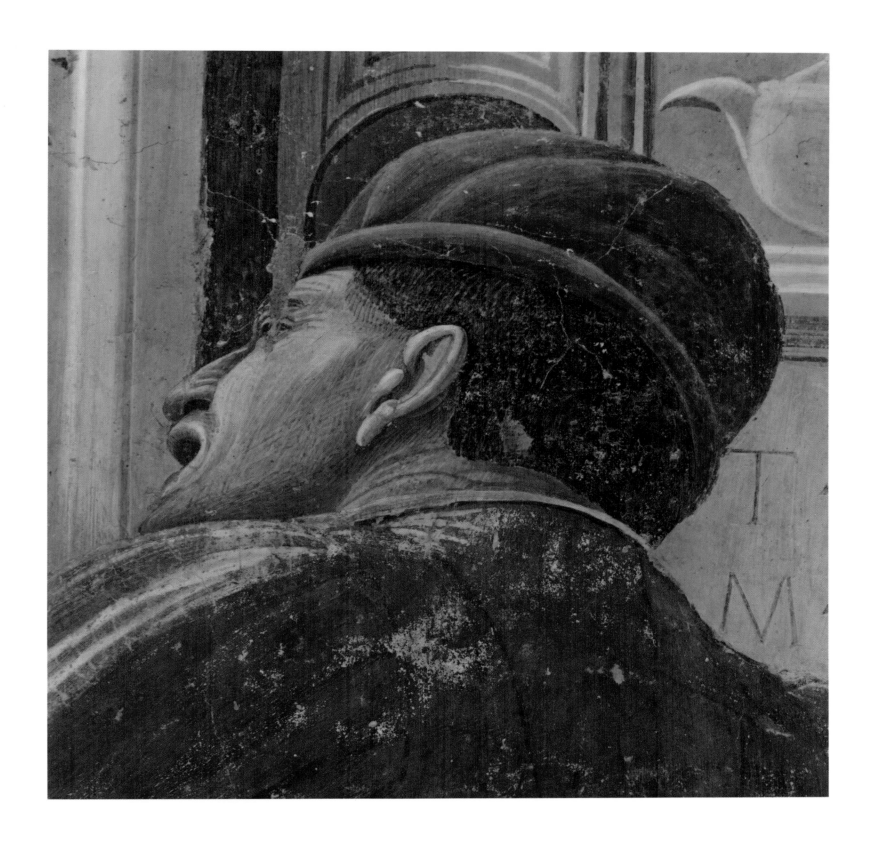

Plate XXI. Detail from *St. Christopher's Body Being Dragged away after his Beheading* (Plate XVII).

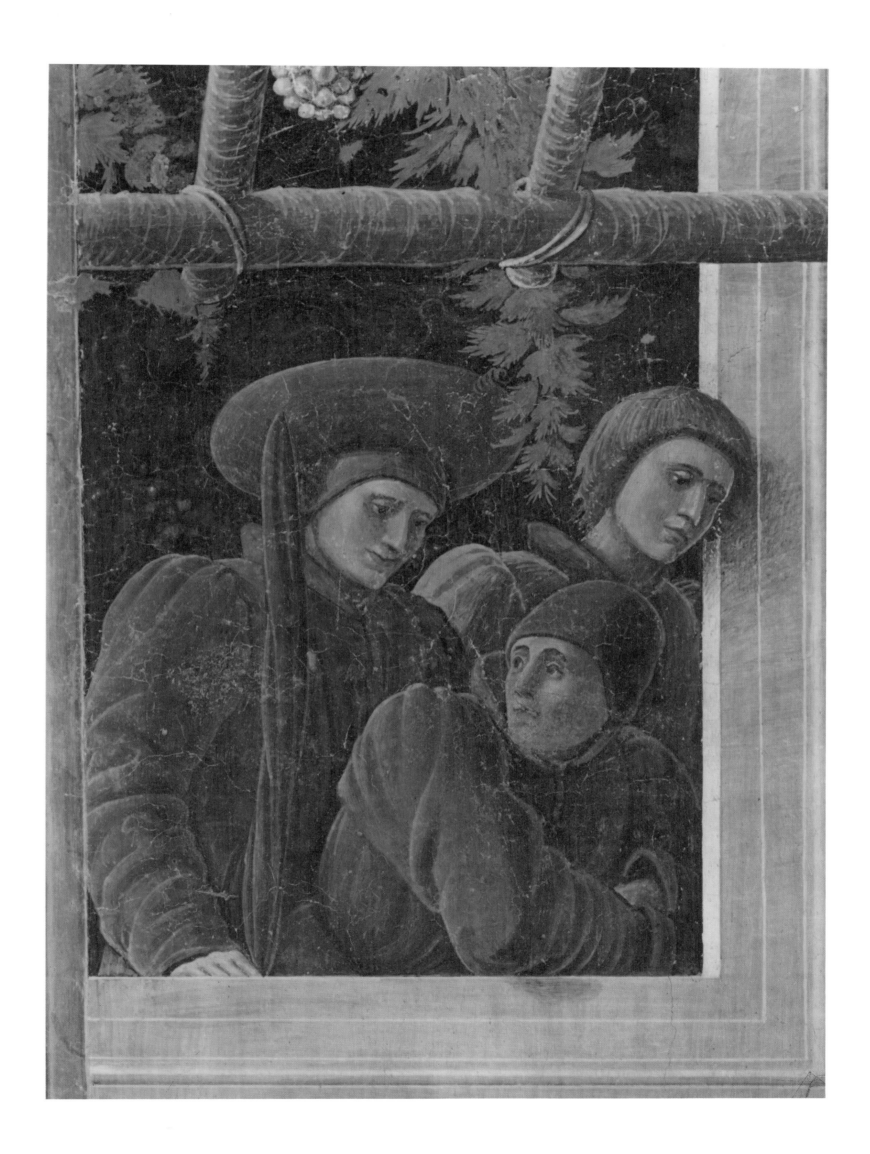

Plate XXII. Detail from *St. Christopher's Body Being Dragged away after his Beheading* (Plate XVII).

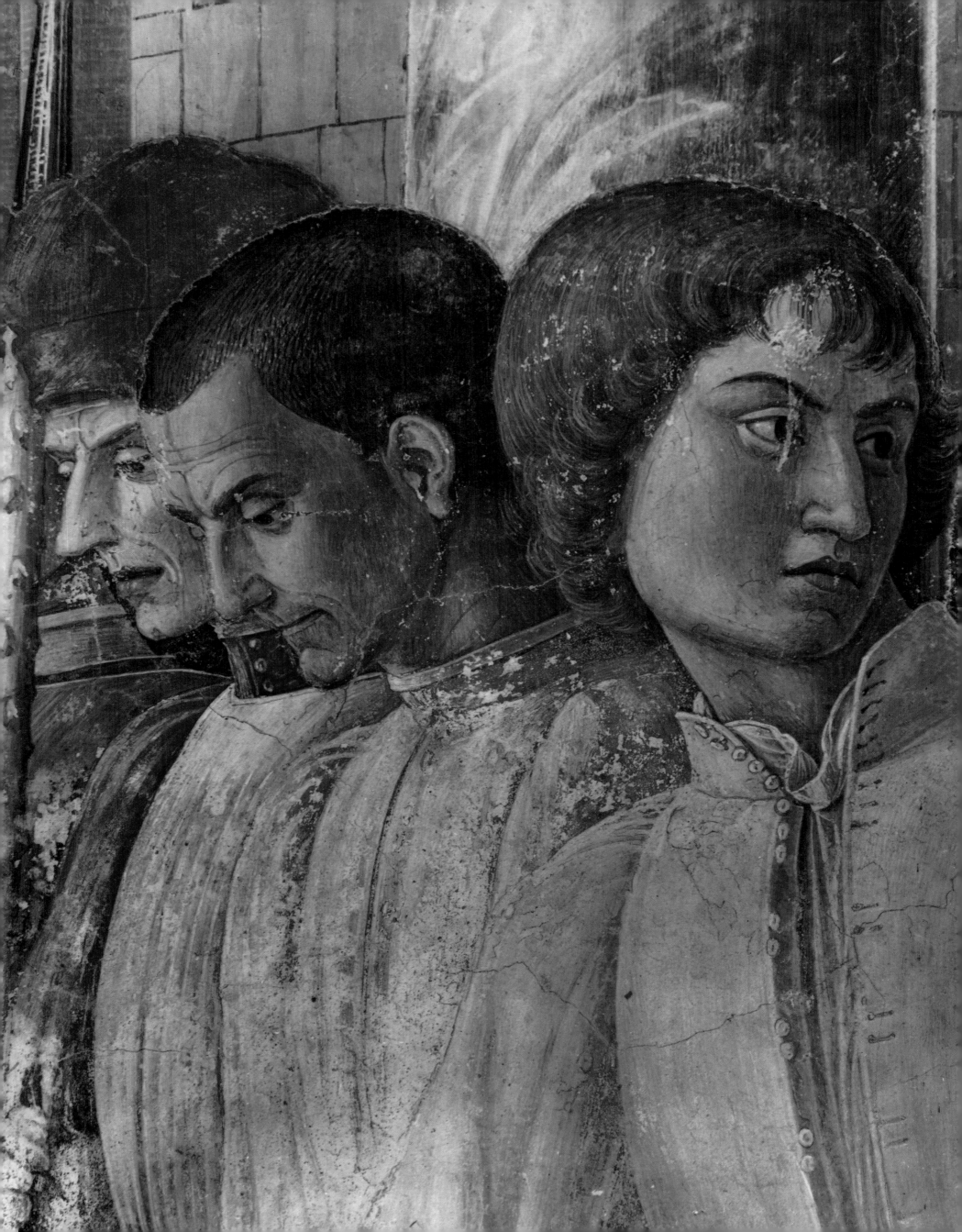

Plate XXIII. Detail from *St. Christopher's Body Being Dragged away after his Beheading* (Plate XVII).

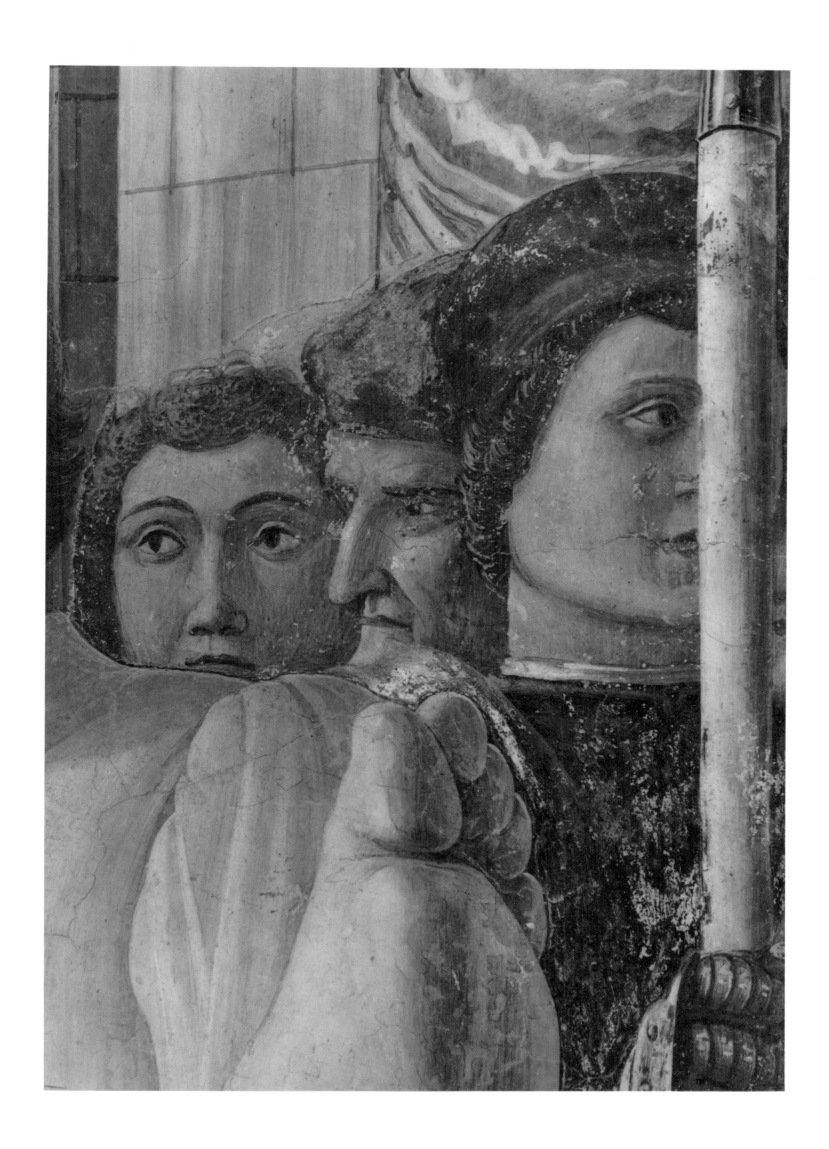

Plate XXIV. Detail from *St. Christopher's Body Being Dragged away after his Beheading* (Plate XVII).

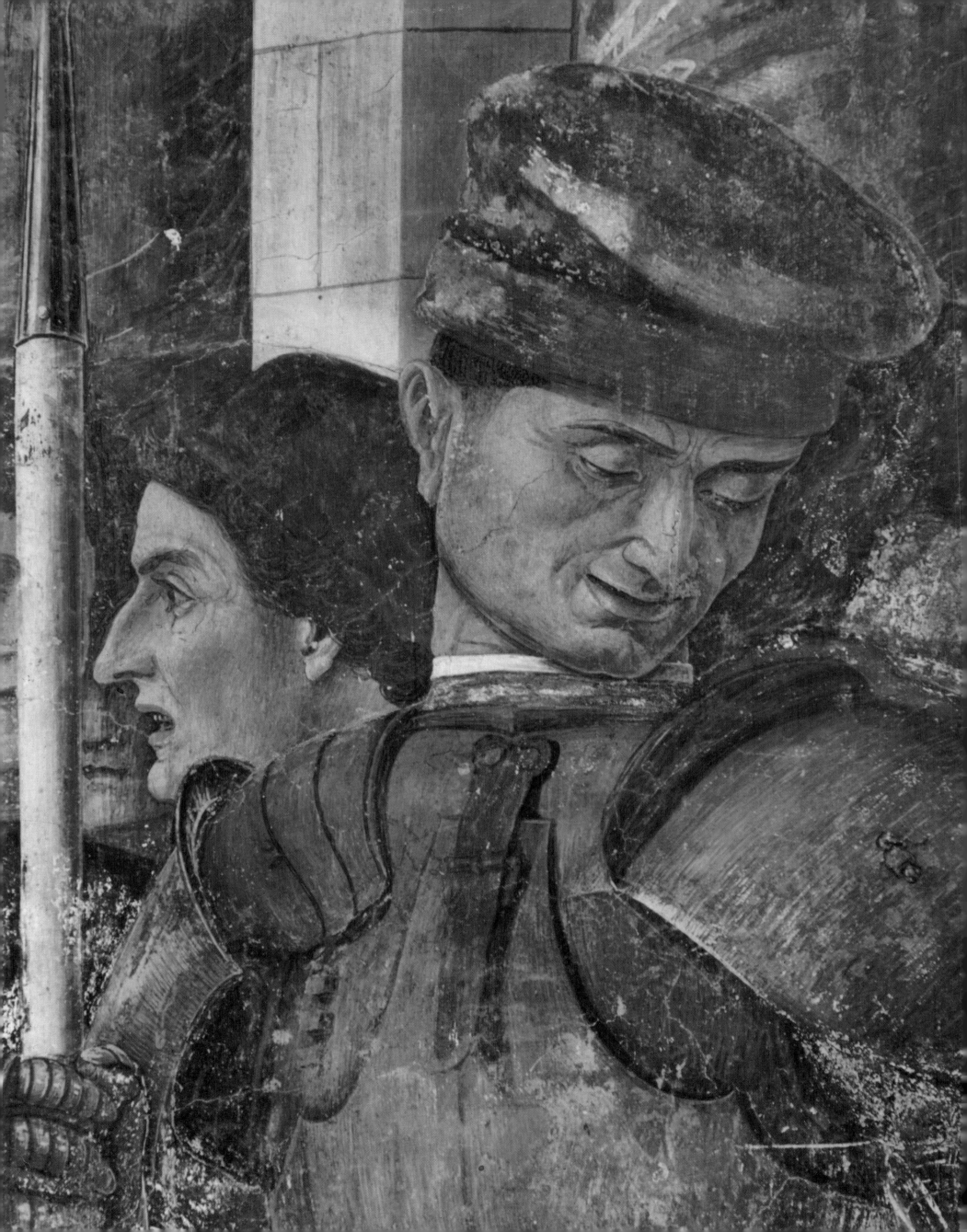

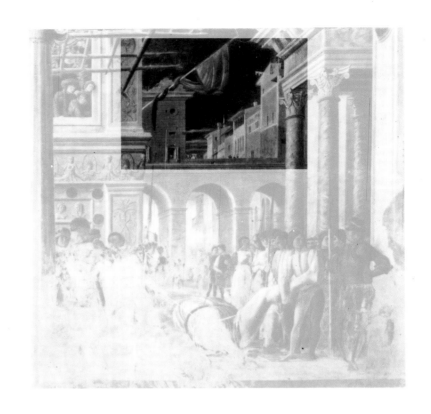

Plate XXV. Detail from *St. Christopher's Body Being Dragged away after his Beheading* (Plate XVII).

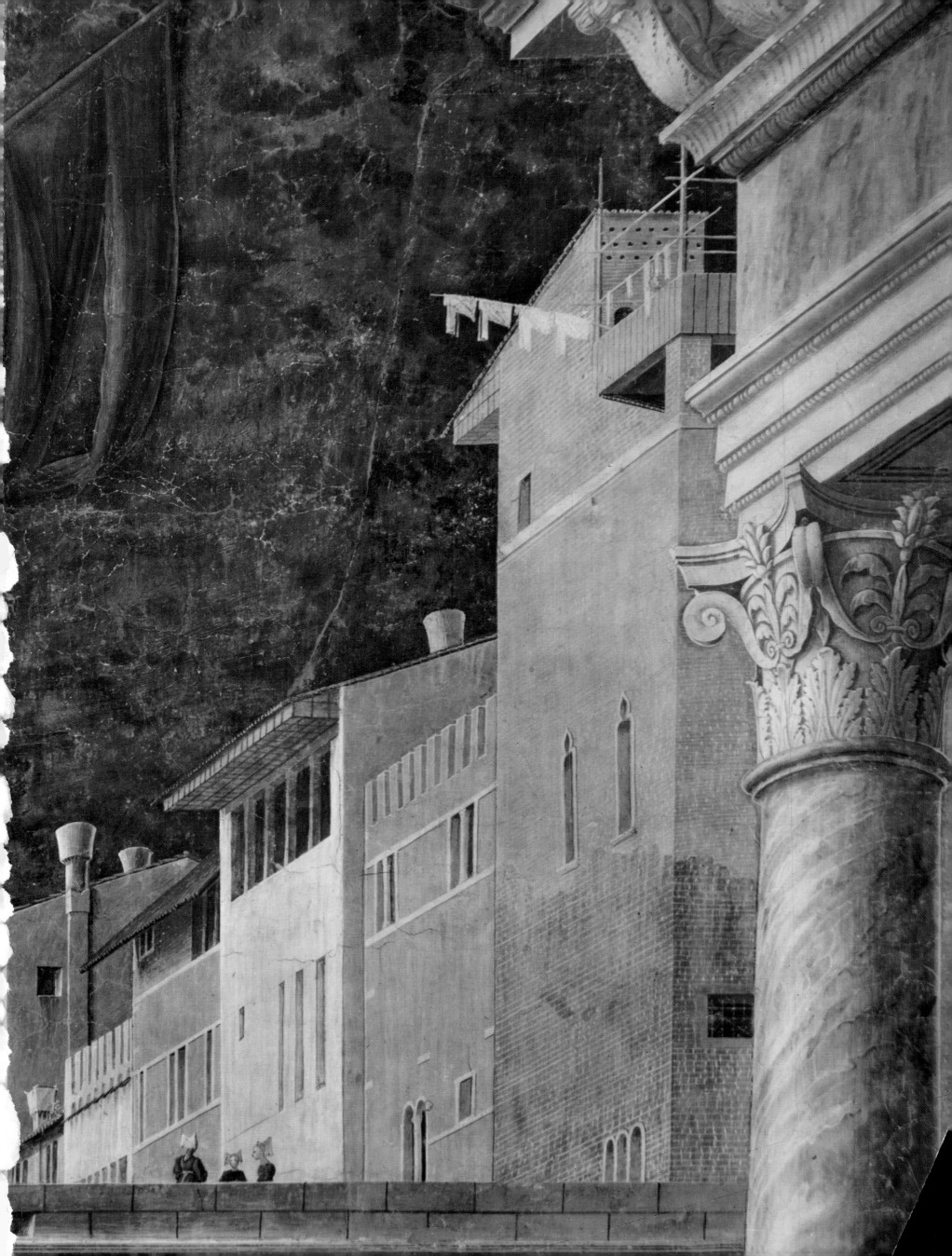

LIST OF COLOUR PLATES

LIST OF BLACK AND WHITE ILLUSTRATIONS